Historic
Canada

CAMPOBELLO
ISLAND

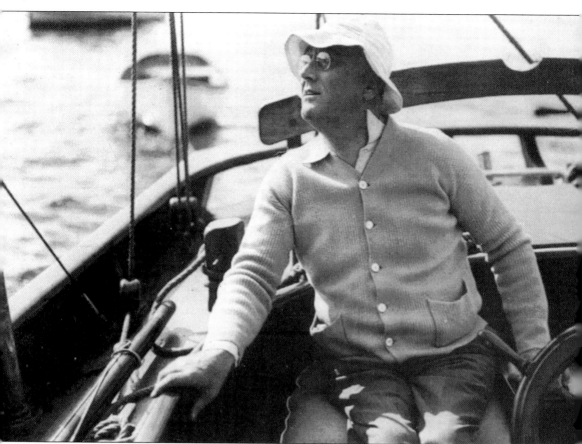

Franklin Delano Roosevelt, aboard the *Amberjack II* in June 1933, sails in to his beloved Campobello Island. This was his first visit back to the island since having been stricken with polio in 1921, as well as his first visit as the newly elected president of the United States.

Historic
Canada

CAMPOBELLO ISLAND

Jim Harnedy and Jane Diggins Harnedy
Campobello Public Library and Museum

ARCADIA
PUBLISHING

Copyright © 2002 by Jim Harnedy and Jane Diggins Harnedy/Campobello Public Library
 and Museum
ISBN 978-0-7385-1147-4

Published by Arcadia Publishing
Charleston, South Carolina

Printed in the United States of America

Library of Congress Catalog Card Number: 2001097952

For all general information contact Arcadia Publishing at:
Telephone 843-853-2070
Fax 843-853-0044
E-mail sales@arcadiapublishing.com
For customer service and orders:
Toll-Free 1-888-313-2665

Visit us on the Internet at www.arcadiapublishing.com

CONTENTS

For our family, past and present, who hailed from the Maritimes:
the Diggins of Nova Scotia, the Donovans of New Brunswick,
and the McEacherns of Prince Edward Island.

INTRODUCTION

Both history and legend abound on Campobello Island, New Brunswick. Over the years, the island has been known by many names. The Indian name for it was Abahquict, meaning "along or parallel to the mainland." The early French settlers of the Passamaquoddy Region called it Port aux Coquilles, and the English named it the Outer Island of Passamaquoddy.

Geographically, Campobello Island rises on the outer edge of Passamaquoddy Bay, two miles across the bay from Eastport, Maine. At the island's Narrows, Lubec, Maine, is a stone's throw away, though it was not until 1962 that a bridge connected the island to the mainland. Prior to the bridge, both island residents and visitors were totally dependent on ferry service or private boats for transportation on and off the island. The island is nine miles long and about three miles wide at the widest point. It has two picturesque fishing villages, Welshpool and Wilson's Beach. Both are home port to many fishing vessels that ply the waters of the Bay of Fundy.

While the Mic Macs lay claim to having been the original settlers of the area, later followed by the Abenakis, there is no physical evidence that Indians ever used the island as a permanent settlement. Large refuse heaps of discarded clamshells found along the shoreline attest to their returning year after year to get clams. They also most likely hunted and collected sweet grass to make baskets during the summer before returning to the mainland for the winter. The fact that there is no trace of a burial ground supports the case that no permanent settlement was ever made.

It is possible that Norsemen may have ventured onto Campobello Island during one of their treks along North America's eastern shores, but no runic inscriptions or other telltale evidence of their visits has ever been discovered.

Samuel de Champlain and his fellow French explorer Sieur de Monts extended their explorations for France into the Bay of Fundy. In 1604, the pair founded an ill-fated colony at the mouth of the St. Croix River. In addition, they claimed the total Passamaquoddy Region for France. British ownership of the island came as an outcome of the Treaty of Utrecht in 1713; however, it was not until Wolfe defeated the French at Quebec in 1759 that final settlement came.

James Boud, from Kilmarnock, Ireland, is the first known person from the British Isles to settle in the Passamaquoddy Bay Region. He arrived in 1760. Ten years later, a Welshman by the name of William Owen, a captain who had served in India, requested a land grant and eventually received a deed to 12,000 acres on Outer Island (Campobello). Owen was a very well-organized man and, shortly after his arrival, established plans for the new settlement, including detailed legal procedures for the area. He named his island settlement Campo Bello after his beneficiary and friend, Gov. William Campbell of Nova Scotia.

During the American Revolution, the island became a rallying haven for British loyalists. Many New England loyalists sought sanctuary during those times in New Brunswick and Nova Scotia, with some settling on Campobello. The War of 1812 brought to an end a lucrative smuggling operation that had flourished on the island. Smuggling had provided a degree of economic freedom to local islanders from the island's feudal owner, Capt. David Owen, William Owen's nephew.

For purposes of establishing international boundaries between the United States and Canada in the region, Daniel Webster was appointed to lead the American delegation for settlement of this issue. Webster was a poor sailor, however, who, while sailing down the St. Croix River, ran into rough waters. He balked at sailing out farther into the bay and insisted on hugging the Maine shoreline south of the Narrows. This left Campobello Island in Canada, although it more logically should have been placed in American territory.

Most of the years between establishment of the island as a Canadian territory and its sale in 1880 were slow. There were two significant events during this period. In the 1830s, the first and only murder occurred on Campobello when a carpenter named Dunbar of Mill Cove killed his wife, salted her body in a pork barrel, and hid it in the cellar below the kitchen. He was brought to justice after a long search. A pot of gold that Dunbar's wife had allegedly hidden from him was never found. Ironically, Dunbar was hanged on a gallows that he had constructed.

In the spring of 1866, an armed band of Irish Americans known as the Fenians, many of whom had fought as Union soldiers during the American Civil War, assembled in eastern Maine, determined to seize and occupy Campobello Island as a way of harassing the British, who they continued to see as their enemy. Bernard Doran Killian plotted the escapade. The Fenians ranks were filled with spies and informers. Both the British and American governments were aware of the planned event. The United States sent Gen. George G. Meade with 300 troops to enforce the Neutrality Act, which had established a peaceful border between the two nations. The Fenians thought that their scheme would re-enforce the popular American expansionism movement of the time, but they were wrong and it was a total failure. The event became known as the "Eastport fizzle."

In 1880, a group of businessmen offered to purchase the entire island from the widow of Capt. Robinson Owen. Mrs. Owen welcomed the sale and the American syndicate finalized the deal in 1881 and launched the development of the island as a summer colony.

To respond to the needs of the hoards of new visitors to the island, the Eastern Steamship Company began providing service from Boston to Eastport, service that continued for five decades. Ferry service between Eastport and Campobello during this period also made travel for summer vacationers easy. Train service into Eastport, as well as ferry service between Lubec, St. Andrews, and Campobello, was also available.

In recent memory, the island has been known as a summer retreat for a well-known and much loved visitor. James and Sara Roosevelt, parents of Franklin Delano Roosevelt, purchased land and built a summer cottage on the island. It is here that the future president of the United States learned to swim and sail. It was also on the island that Dore Schary's stage play *Sunrise at Campobello* was turned into a major motion picture in 1960, starring Greer Garson and Ralph Bellamy as Eleanor and Franklin Delano Roosevelt.

The island continues to attract famous and not-so-famous visitors every year. In 1962, the Franklin Delano Roosevelt International Bridge was opened linking Lubec, Maine, to Campobello Island, and opening the island to easy access via automobile. Two years later, Roosevelt Campobello International Park was established. The only international park in the world, it is visited annually by about 150,000 people from mid-May to mid-October.

One

THE OWENS ERA

Capt. William Owen hailed from a well-known and affluent Welsh family. Some members of the family were landed gentry; his brother Edward Owen had served as rector of Warrington. Captain Owen had distinguished himself in service with the royal navy and had lost an arm during a battle in India. Upon his return to England, however, no promotions or appointments were forthcoming as rewards for his service. It was not until 1767, through his friend and beneficiary Lord William Campbell, the governor of Nova Scotia, that he received a royal grant to 12,000 acres on what was then called Outer Island. Owen renamed the Island Campo Bello in honor and thanks to his friend Campbell.

In January 1770, Owen purchased a three-masted brig, called a snow, which he named the *Owen*. For his planned settlement he advertised and signed up 38 men and women as indentured servants to accompany him as settlers. The *Owen* set sail on April 6, 1770, with a Captain Denny as the ship's master—though Owen remained in charge. The ship ran into stormy weather and heavy seas a few days out from Liverpool but sailed into Halifax Harbour on May 21, 1770. On June 3, the *Owen* finally put down anchor at Campo Bello.

To Owen's surprise, he found three families—those of Robert Wilson, William Clark, and William Ricker—living illegally on his island. They had moved to the island from New England and settled in the Wilson's Beach area in 1766. They soon acquiesced to the jurisdictional control of Owen, whose family continued to rule the island as a fiefdom for the next 110 years.

List of my Indentured
Servants at Campo Bello

No.	Names	Quality or Trades	Rates of Wages
1	Wm. Isherwood Esqr.	Clerk and Assistant	£60 — increased to £100 p. Ann.
2	John Montgomery	— My Servant	
3	Sarah Haslam	Housekeeper	
4	Jane Johnson	House-maid	1 s 6 d p. Week
5	Richd. Atwood	Armourer & Blacksmith	7,, — do.
6	Willm. Rylands	Fisherman & Net-weaver	6,, — do.
7	Evan Williams	do. — do.	6,, — do.
8	Wm. Drinkwater	Husbandman & Labourer	6,, — do.
9	John Drinkwater	do. — do.	6,, — do.
10	Benjamin Matiner	Butcher	6,, — do.
11	Chas. Whitnell	Brick-moulder, burner and Labr. also Shoemaker	6,, — do.
12	Lewis Jones	Mariner & Fisherman	6,, — do.
13	John Holliday	Shipwright, Caulker & Seaman	3£ p. month
14	Joseph Caldwell	Taylor	6 s. week
15	John Lawless	Barber and Gardener	6 — do.
16	Catherine Lawless		
17	Mary Lawless		
18	Elizabeth Whittal	Cooks, Housewives, Washerwomen	At 2 s & 1 s 6 d each p. week
19	Eleanor Newell	and Spruce-beer brewers	
20	Mary Jones		
21	James Gregson	Labourer	6 s p. week
22	John Clark	Husbandman & Labourer	6 — do.
23	Richd. Clayton	— do. — do.	4 — do.
24	John Unsworth	Carpr., Joiner, & Boat-builder	8 — do.
25	John Clotton	do. — do. — do.	8 — do.
26	John Lockitt	Ploughman & Labourer	6 — do.
27	Wm. Mollineaux	Pot-ash burner	6 — do.
28	Willm. Douglas	Miller & Hushandman	6 — do.
29	Thomas Green	Cooper and Labourer	6 — do.
30	Thos. Gregory	Carpr., Joiner & Wheelwright	8 — do.
31	John Hurst	Ploughman & Gardner	6 — do.
32	James Bate	Gardner, Claycaster & Delvor	6 — do.
33	Joseph Henshaw	Brick-layer, maker & burner	9 — do.
34	John Robotham	Potter and Labourer	6 — do.
35	Adam Kingsley	Mason, Slater & Plaisterer	£25 p. Ann
36	Nicholas Rollin	Fisherman and Labourer	13 s 6 d p. Month
37	Edmund Mahar	Labourer	£1 11s 6 d do.
38	John Pendergrass	Fisherman	£1 0,, 0,, do. 2

Capt. William Owen kept detailed records of all his transactions. He advertised for indentured servants to accompany him and help settle Campobello Island. Taken from his journal is the list of the 38 men and women who signed on. On March 30, 1770, the entire group hiked from Warrington to Liverpool for embarkation to Campobello Island.

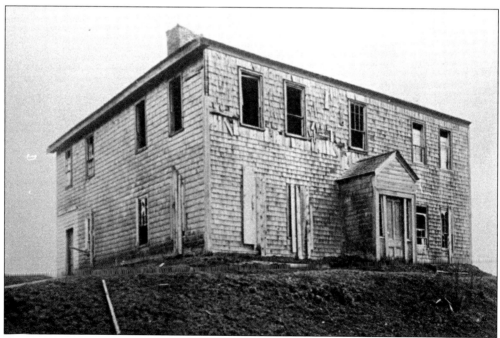

American traitor Benedict Arnold lived in this home in Snug Cove with his wife, Peggy Shippen of Philadelphia, from 1789 to 1793.

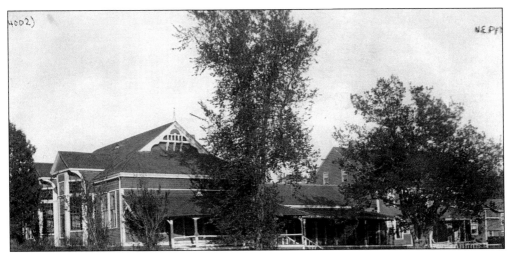

In 1835, Adm. William Fitzwilliam Owen arrived on the island with his wife and two daughters to take over the reigns of the family's feudal domain. He was a famous cartographer whose name appears on many maps of North America and Africa. A very ambitious man, Owen built roads, wharves, St. Anne's Anglican Church, and his own home, above.

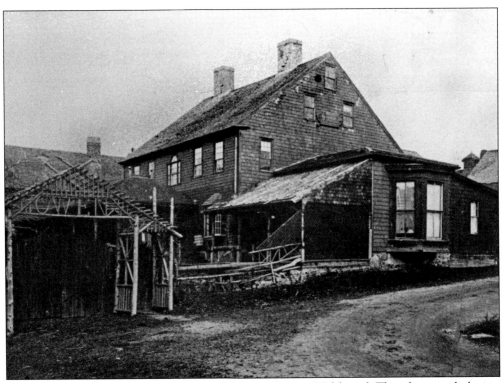

Admiral Owen built his residence in 1835 at Deer Point in Welshpool. This photograph depicts the residence c. 1900. A section of the original home was moved up the hill c. 1915 to become part of the present-day Owen House, a country inn and gallery.

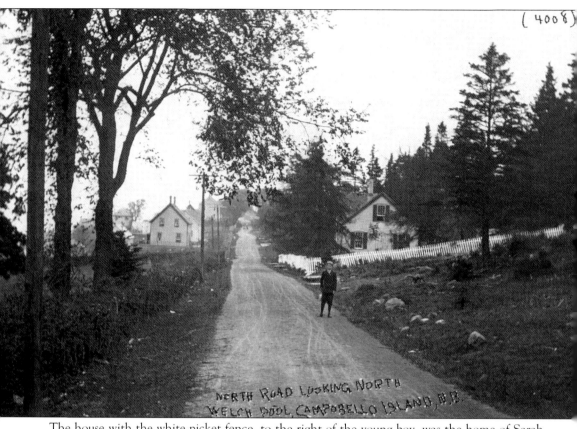

NORTH ROAD LOOKING NORTH
WELCH POOL, CAMPOBELLO ISLAND, N.B.

The house with the white picket fence, to the right of the young boy, was the home of Sarah and Luke Byron. Luke Byron was a barrister as well as a tutor to the children of Capt. Robinson Owen, a descendant of William Fitzwilliam Owen, recognized illegitimate son of Campobello Island colony founder William Owen. The photograph depicts a view looking north on North Road in Welshpool in the late 1870s.

Two

SUMMER DAYS PAST

In 1880, a group of men from Boston and New York initiated negotiations with the widow of Capt. Robinson Owen to purchase Campobello Island. In 1881, the American syndicate finalized the sale with Lady Owen, allowing her to return home to England. This ended the feudal saga of the Owen family on Campobello Island and launched the development of the island as a summer colony that would cater to wealthy families from Boston, Montreal, New York, and Philadelphia.

The Campobello Land Company constructed hotels, the Ty'n-y-Coed and the Ty'n-y-Maes (Welsh for "house in the woods" and "house in the meadow," respectively), the Hotel Owen, and private cottages for wealthy families who wished to escape the heat of summer in the cities. James and Sara Roosevelt, parents of the future American president Franklin Delano Roosevelt, were among those who purchased land and built a cottage on the island. Luxury and elegance were the hallmark of this period. Steamship service from Boston to Eastport, Maine, with interconnection to ferry service to Campobello Island, along with train service to Eastport and ferry service between Lubec and St. Andrews to the island, made travel for summer vacationers easy.

The good times for the summer colony lasted approximately 30 years, ending with the start of World War I. Alex S. Porter, the founder of the Campobello Land Company, which had developed the summer colony, died in 1915. Shortly after Porter's death, the company was sold to a New York group that operated the resort until 1930.

Although the golden days of elegant vacation life at the island's wonderful hotels ended, people who lived on the island had been permanently introduced to a new way of life and commerce. Tourism was to become another staple in Campobello Island's industry. Most local residents became either directly or indirectly involved in this sector of the island's economy and have participated in many of the summer activities that were introduced.

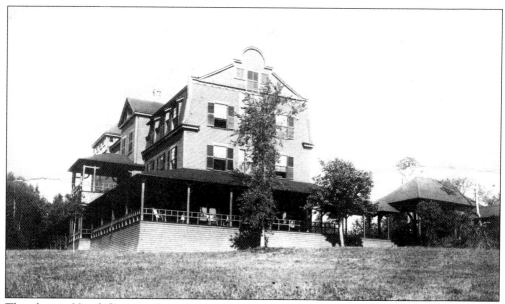

The elegant Hotel Owen at Deer Point, shown c. 1890, was one of the hotels constructed by the Campobello Land Company to encourage tourism to the island.

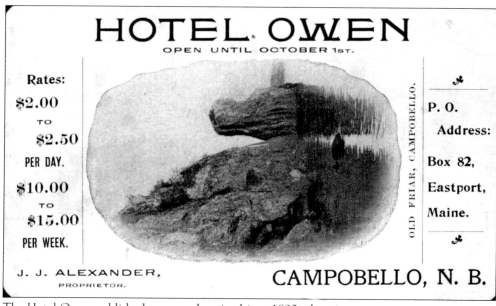

The Hotel Owen published rates, such as in this c. 1890 advertisement.

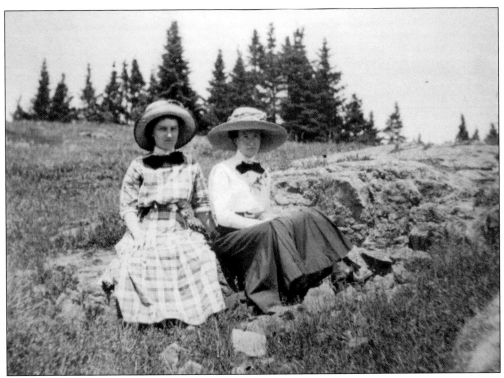

Two women enjoy a delightful summer day on Campobello Island *c*. 1890.

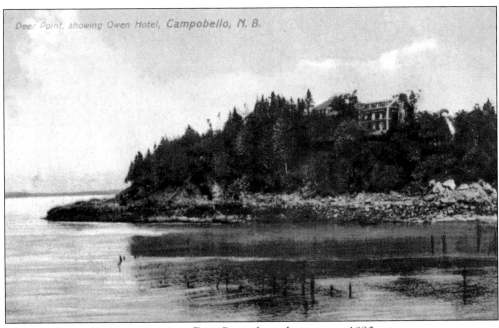

Deer Point, showing Owen Hotel, Campobello, N. B.

The Hotel Owen is seen at pristine Deer Point from the water *c*. 1890.

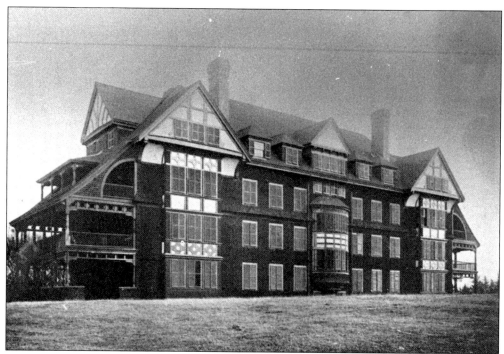

The posh Ty'n-y-Maes Hotel was one of the hotels built in the 1880s by the Campobello Land Company as part of its development of the island as a summer colony.

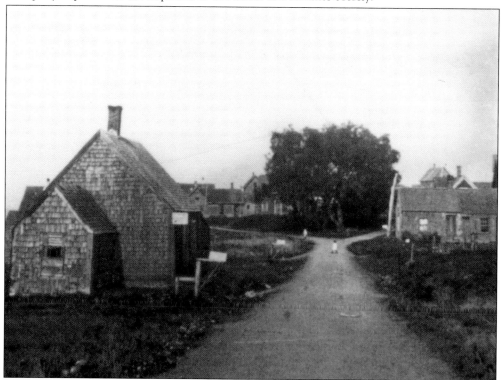

This c. 1890 photograph reflects life at Wilson's Beach.

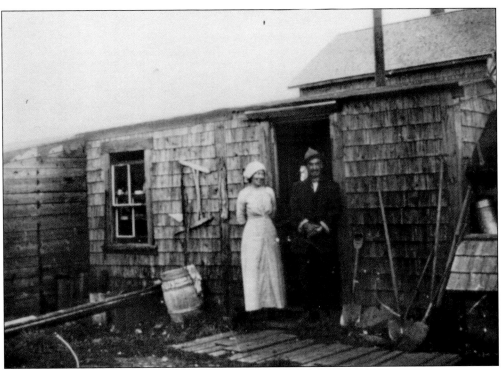

An unidentified couple stands in front of a Wilson's Beach home *c.* 1890.

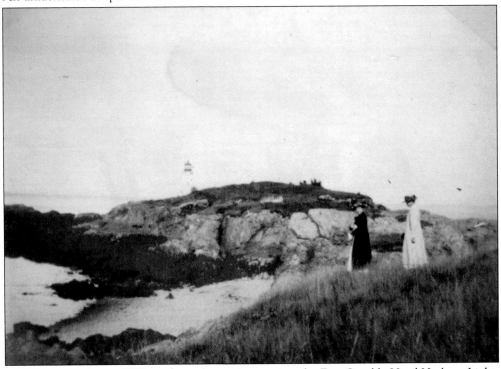

Two women enjoy an 1890s summer day outing to view the East Quoddy Head Harbour Light. This summer pastime is repeated by visitors to Campobello Island each season.

Two summer visitors explore the pristine beauty of Campobello Island c. 1890.

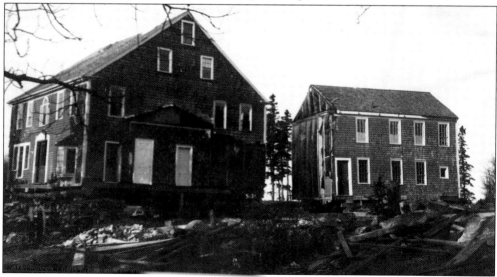

The building to the right is a major section of Adm. William Fitzwilliam Owen's mansion. It was moved from its original location up the hill c. 1915 by H. Morton Merriman, who had purchased Deer Point. The Admiral William Fitzwilliam Owen home was carefully joined to the existing home to become the Owen House. This 167-year-old historical house has been an inn since 1974. It was operated for many years by Mr. and Mrs. Wayne B. Morrell, and is today by their daughter, Joyce Morrell, an artist, who has added a gallery to the property.

This is an interior view of a section of the admiral's home.

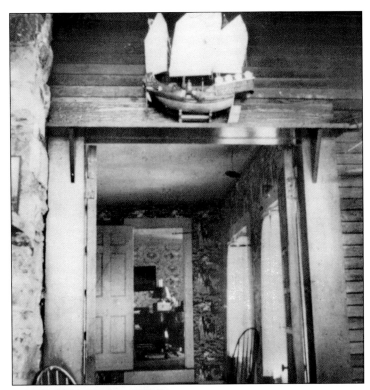

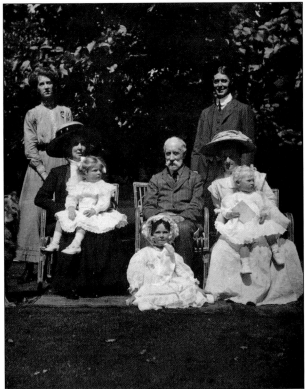

Cornelia Ramsay Cochrane, second from left, was born on Campobello Island in 1847. She was the daughter of Lady and Capt. Robinson Owen, the last of the Owen family to govern their island fiefdom. She was a benefactor to St. Timothy's Catholic Church; a plaque honouring her generosity was dedicated in the church by her daughter Grizal, left. Cornelia Ramsay Cochrane died in Windlesham, Surrey, England, in 1925. Sitting next to her in this early-1900s photograph is her husband, Admiral Cochrane, and surrounding him is their son Archibald Cochrane and his wife and three children.

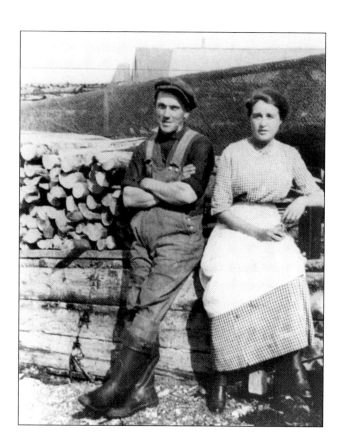

Atwood and Ruby Savage are shown at Pollock Cove during the summer of 1920.

Wallace Ethelbert "Ep" Savage was a baby when this photograph was taken during the summer of 1922 on the lawn at Jackson's Lane (Cooks Point Lane). Savage was the son of Atwood and Ruby Savage.

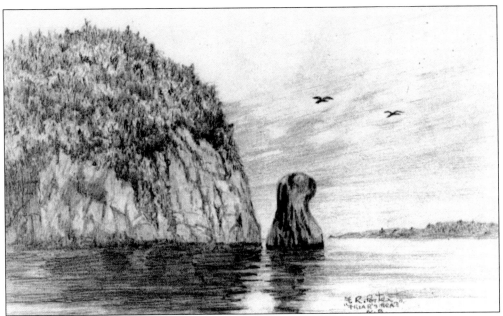

This depiction of Campobello Island's famous Friar's Head is a line drawing by Mary Otis Porter, daughter of Alex S. Porter, the founder of the Campobello Land Company. This natural icon is a must-see for summer visitors. Mary Otis Porter was a woman of many talents. In addition to being an accomplished artist, she was co-founder of the Campobello Public Library and served as the librarian for 54 years.

A pair of oxen heads out for a day of haying during an early-1930s summer. Modern harvesting equipment was still not part of the island farming culture during this time.

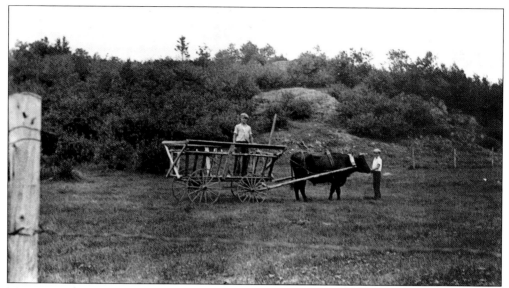

Men get ready to load the hay on a sunny 1930s summer day.

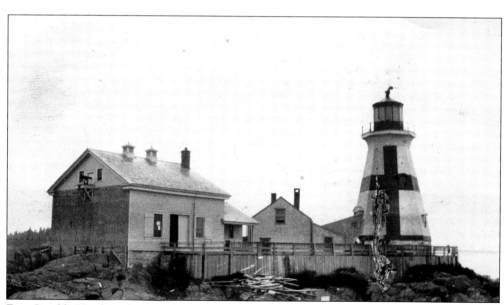

East Quoddy Head Harbour Light—the most photographed lighthouse in New Brunswick—is shown c. 1930.

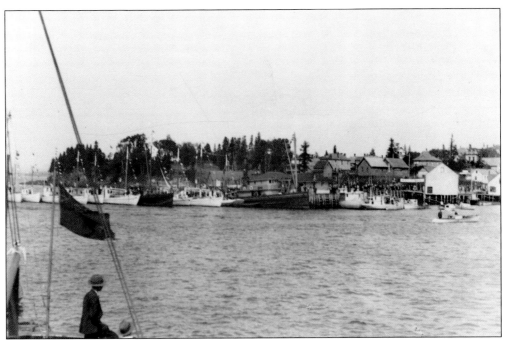

Looking towards Welshpool from the water, one can see the Owen House on the left. This photograph was taken during the 1930s.

Courtney Newman keeps cool on a warm summer day in 1930.

Taking a cool dip has always been a special treat for locals and visitors on hot summer days. This photograph was taken in 1934.

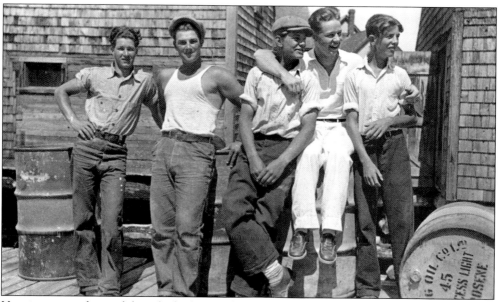

Hanging out in front of the salt sheds at Wilson's Beach during the summer of 1935 are, from left to right, Winslow Newman, "Bud" Mitchell, Marvin Mathews, Bill ?, and S. Mathews.

Courtney Newman and a friend visiting from Boston enjoy a day at Mill Cove during the summer of 1935.

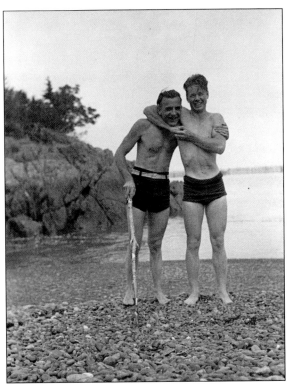

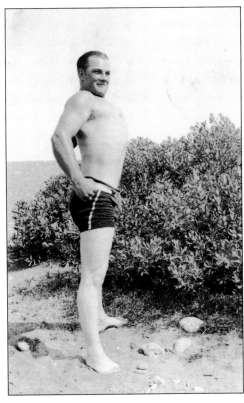

Bud Mitchell strikes a pose on a summer day c. 1940.

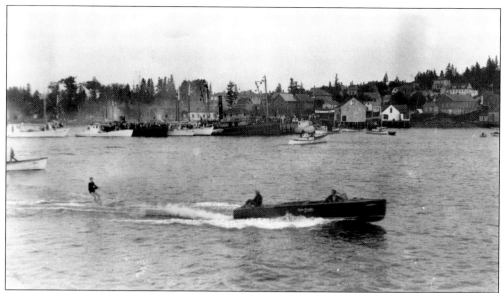

Water-skiing came to the island as a summer sport during the early 1950s. The photograph also includes sardine boats, which were once a mainstay of the fishing economy on the island.

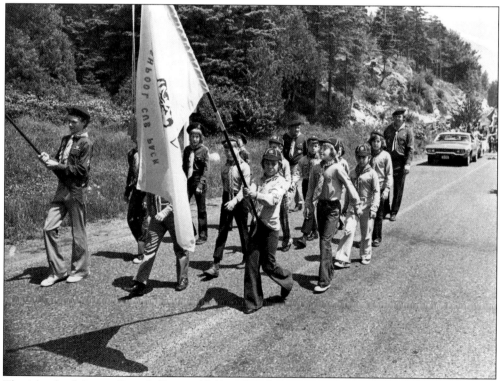

The island celebrates Canada Day in 1960 with a festive parade.

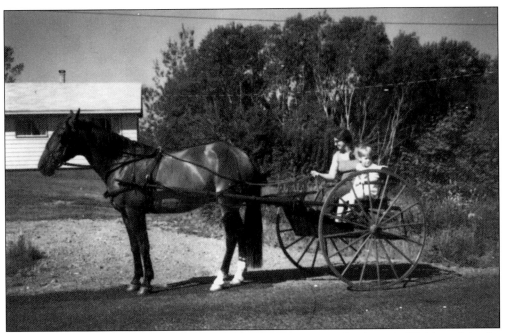

Joyce Morrell and a young neighbour are out for a carriage ride through Welshpool in the 1960s. Morrell's horse Richard gave frequent rides around the island.

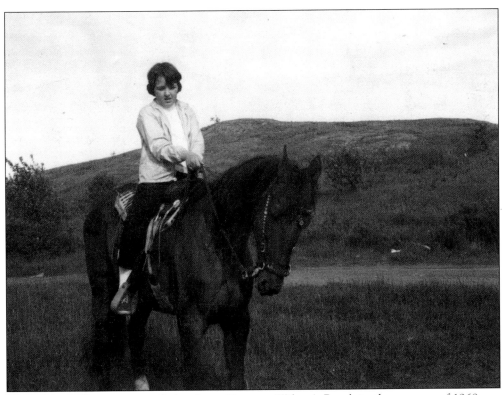

Kathy Savage Smart sits astride her horse Dusty at Wilson's Beach in the summer of 1968.

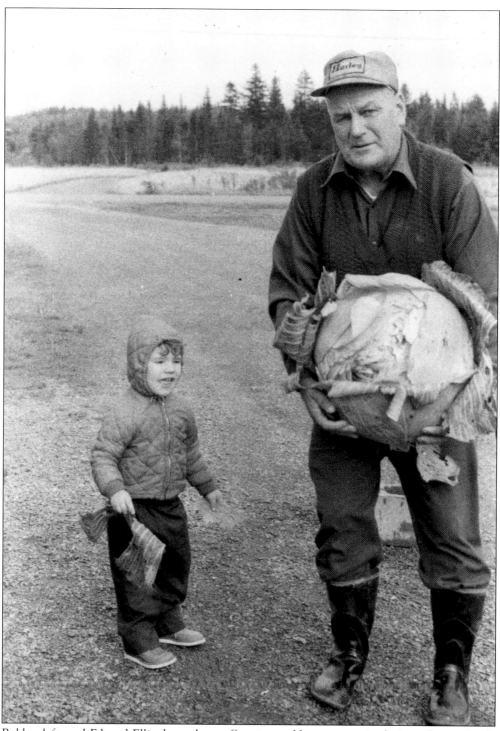

Bobby, left, and Edward Ellingham show off a giant cabbage grown in their garden at Friar's Bay.

Three

WE WORSHIP HERE

The earliest reference to religious life on Campobello Island can be traced to the journal of Capt. William Owen. He recorded that he had conducted a service in a shed for all the members of his new settlement on June 10, 1770, just a few days after their arrival. Although an Anglican presence on Campobello dates to this 18th-century period, it was not until May 20, 1855, that St. Anne's Anglican Church opened at Welshpool for its first service, with Rev. John S. Williams as resident missionary.

The earliest Baptists on the island came from New England, perhaps descendants of New England loyalists who fled to Campobello Island at the time of the American Revolution. During the 18th century, no church buildings existed on the island, but services were conducted by laymen in local homes. Rev. Peter Malloch became the first permanent Baptist pastor of the Baptist church at Wilson's Beach. In 1854, the church authorized him to unite them with the Free Baptist Conference of New Brunswick. In 1874, North Road Baptist Church was constructed. The congregation welcomed its first permanent pastor, Rev. Robert Wilson, in 1956.

St. Timothy's Catholic Church was built in 1910 by Monsignor O'Flaherty, under the supervision of Bishop Casey. Prior to having a physical church, Mass was celebrated for the island's Catholics at private homes. From 1910 to 1938, St. Timothy's was a mission of St. Andrew's Parish in St. Andrews, New Brunswick. In 1938, the mission assignment was transferred to Holy Rosary Parish in St. Stephen; a year later St. Timothy's was made a mission of the Cathedral Parish in Saint John, New Brunswick.

The newest Christian Community on the island are the Pentecostals. In 1942, Brother Ring came to start his spiritual work at Wilson's Beach. The Pentecostal Church's first permanent pastor was Brother Henry Crocker. Today, Brother Todd McGuire provides for the spiritual needs of Campobello Island Pentecostals.

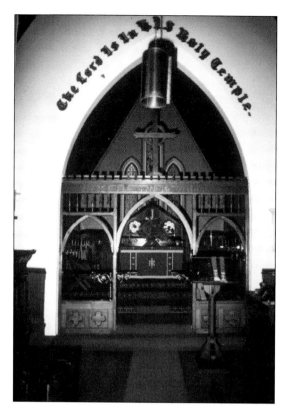

The Church of England's presence on Campobello Island dates to June 10, 1770, when Capt. William Owen conducted the first service. This 1960s photograph is of the interior of St. Anne's Anglican Church.

The Wilson's Beach Baptist Church has been an active Christian community in the area since the early 1800s. According to church history, when Rev. William Carlton arrived in April 1844, he found "fifteen believers" awaiting him. This photograph was taken in 1954.

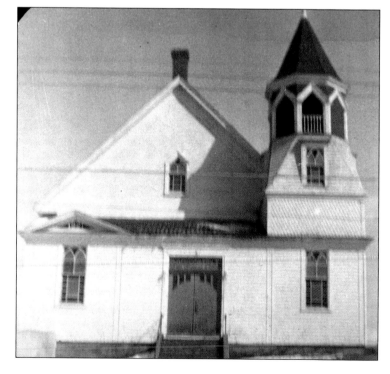

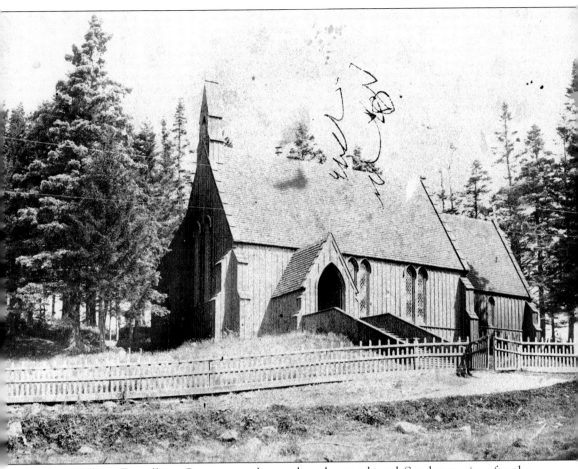

Adm. William Fitzwilliam Owen was a lay reader who conducted Sunday services for the Anglican community for many years. Prior to the erection of St. Anne's Church in 1855, the admiral arranged for an Anglican priest to come to Campobello three or four times a year to administer the sacraments. On May 20, 1855, Rev. John S. Williams conducted the first public service in the newly completed St. Anne's Church.

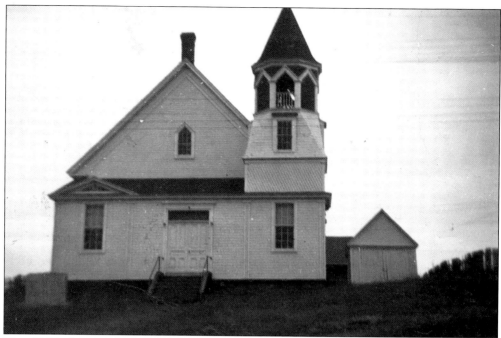

This 1915 photograph shows the Wilson's Beach Baptist Church with a hearse shed. The church community during that time provided a hearse service for Christian funerals.

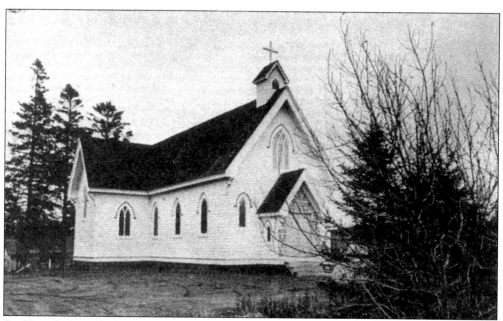

St. Timothy's Catholic Church was built in 1910 to provide for the spiritual needs of the Catholic community on Campobello Island. Prior to having a physical church, Catholics gathered in private homes, where priests from St. Andrews came to say Mass.

In 1963, the altar at St. Timothy's was renovated and stained-glass windows were installed. The windows were obtained from St. Elizabeth's Church in Musquash when it was being torn down.

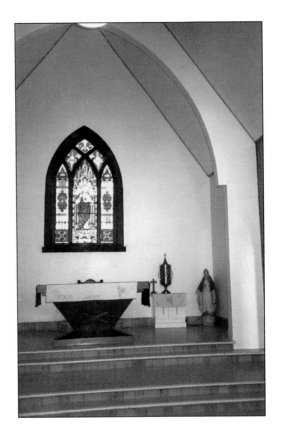

Members of the Wilson's Beach Pentecostal Church community stand in front of the original church building in 1942.

Wilson's Beach Pentecostal Church members shown in this c. 1942 photograph are, from left to right, as follows: (front row) unidentified, Quincy Stair, and Brother Ring (founder of the church); (back row) the first three women to be baptized at the new church, Mrs. Quincy Stair, and Mrs. Ring.

Four

AROUND THE ISLAND

The sea surrounds pristine Campobello Island. Its treasure lies in the beauty of its rocky coastline, bold cliffs, pebble beaches, ponds, Lake Glensevern, Friar's Head, open fields, wooded trails, and bogs. The island lies on the Atlantic flyway and is a stopover destination each year for thousands of migrant birds. Its uniqueness brings thousands of visitors each summer season to experience Campobello Island. Franklin Delano Roosevelt, who vacationed on the island summers from 1883 until he was stricken with polio during the summer of 1921, called Campobello his "beloved island."

Campobello's greatest treasure is much more than great natural beauty. Its warm and generous people have worked hard to maintain a vibrant community. The citizens of Campobello Island have a proud heritage that they continue to pass on to each new generation.

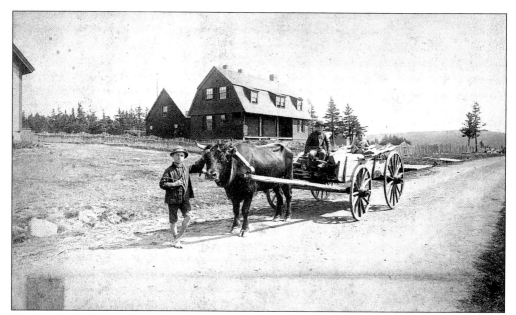

Medley MacLellan strokes the ox pulling the cart that holds his sister and his brother, Frank. The home shown in the 1882 photograph is the rectory of St. Anne's Anglican Church.

Jake Pike is seen in 1888.

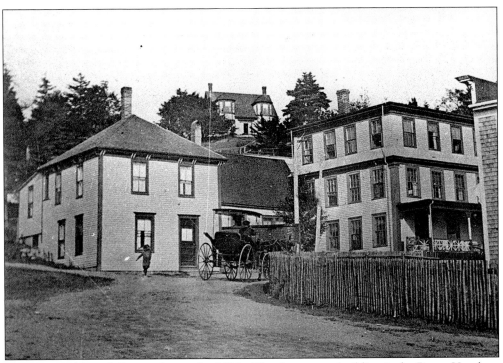

Shown is Welshpool Centre during the 1890s. The three-story building is the Byron Hotel.

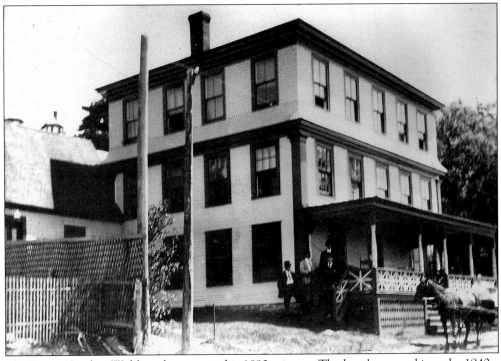

The Byron Hotel in Welshpool is seen in this 1890s picture. The hotel operated into the 1940s.

James Loren Savage and Mary Jane Savage had this portrait taken in 1900.

This c. 1900 photograph taken at Dunn's Beach in Welshpool shows a number of wharves and fish houses that have long since disappeared from the landscape. Included among these is Jim Calder's wharf.

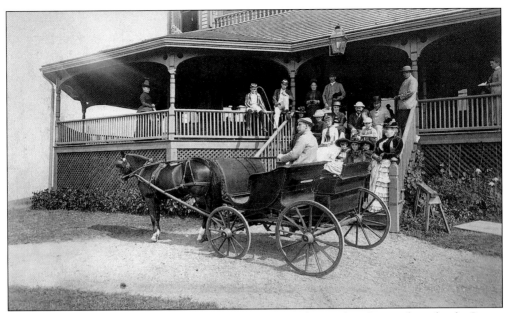

This 1890s picture depicts the golden days of the elegant hotels on the island. Guests enjoy a summer day on the large porch of the Ty'n-y-Coed Hotel. The horse-drawn carriage, which once belonged to Adm. William Fitzwilliam Owen, provided guests with travel around the island.

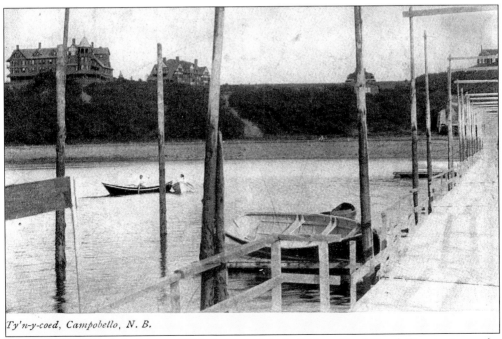

Ty'n-y-coed, Campobello, N. B.

Shown in the upper left of this c. 1900 photograph is the Ty'n-y-Coed Hotel. Continuing to the right are the Ty'n-y-Maer Hotel, the Wells-Schober cottage, and the Hubbard cottage.

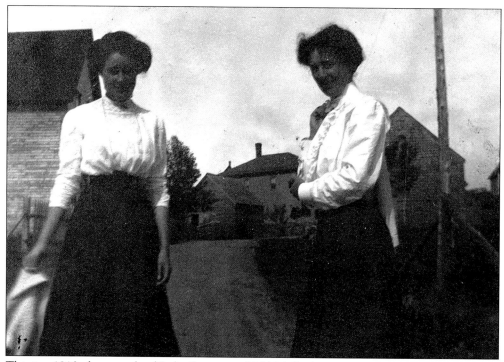

This is a 1910 photograph of Ruby Savage and Mil Mallock.

Frank Lank stands near his North Road residence in the 1920s.

Marvin Mathews strikes a relaxed pose for this late-1920s photograph.

Alva Brown, the owner of a Wilson's Beach store, had this portrait photograph taken during the 1920s.

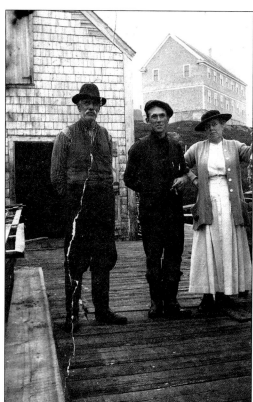

Shown in front of James Loren Savage's fish shed on the wharf at Pollock Cove in the 1920s are, from left to right, James Loren Savage, Atwood Savage, and Elizabeth Brown.

Atwood and Ruby Savage are seen in this 1920s portrait.

Ruby Savage, left, and a neighbour are on Jackson Lane in this 1920s photograph.

Men check out a new car in front of the Campobello Public Library in Welshpool in the 1920s.

Boston visitors sample a drink of water from Campobello Island's famous Barrel Well in 1929.
Legend records that if one has a drink of its water, he or she will return to the island.

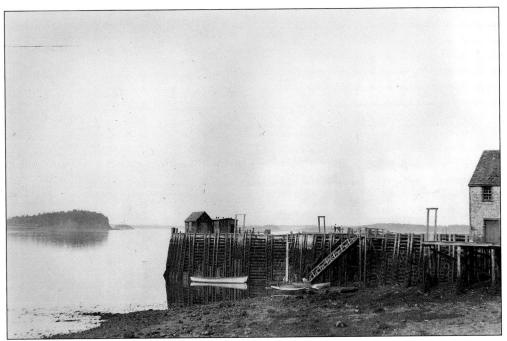

This is low water at the breakwater in the 1920s.

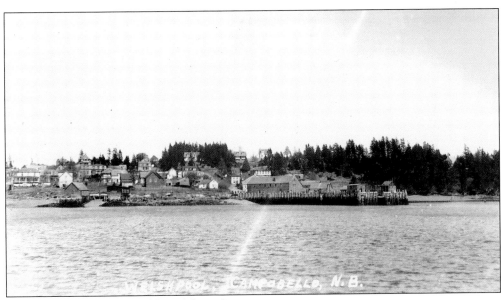

This is a 1930s view of Welshpool from the water.

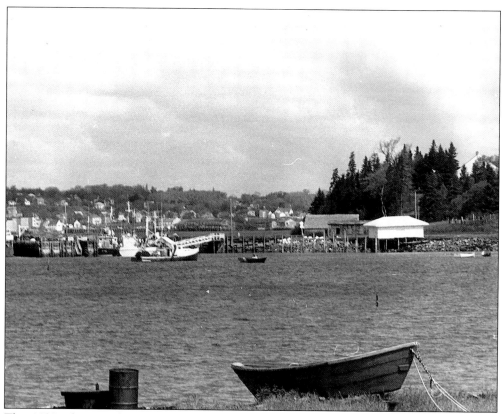

This 1930s photograph provides a look toward Welshpool's breakwater; in the far distance is Eastport, Maine.

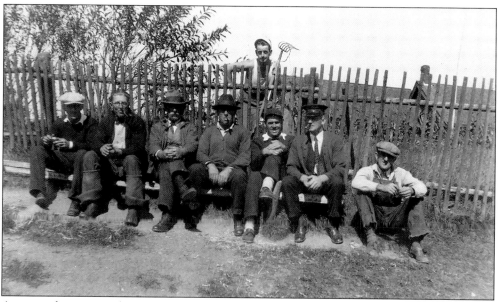

A group of men sit in front of a Welshpool store in the 1930s.

46

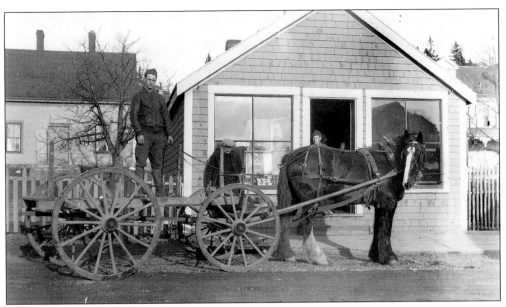

This horse and cart are shown in front of a Welshpool store in the 1930s.

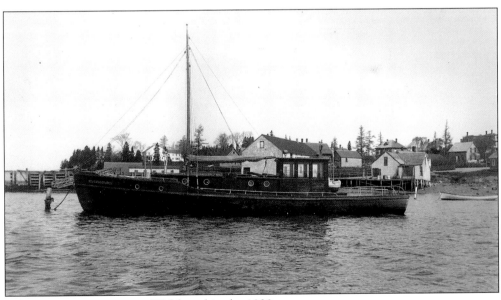

A boat is on its mooring in Welshpool in the 1930s.

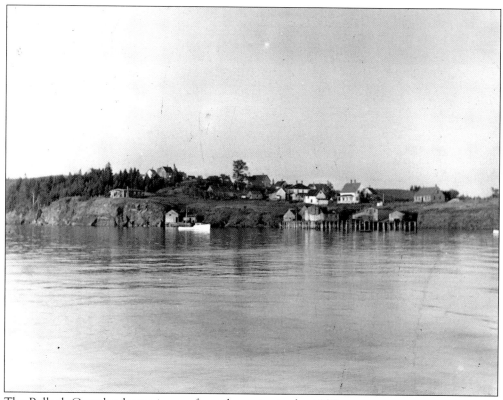

The Pollock Cove landscape is seen from the water in the 1930s.

This is the gentle landscape of Friar's Bay in the 1930s.

A saltwater farm scene on North Road is shown in the 1930s.

This is Harbour de Loutre in the 1930s.

This was the scene at the pebble beach at Mill Cove in the 1930s.

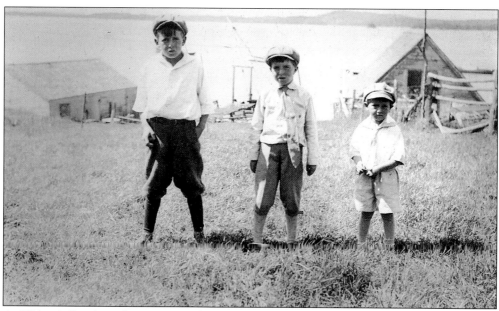

At Wilson's Beach in the 1930s are, from left to right, Leon Newman, Vaughn Newman, and Blair Newman.

This group looks across the water towards North Road in 1939.

At Wilson's Beach in the summer of 1934 are, from left to right, Evie Calder, Courtney Newman, and Pearl Mathews.

Courtney Newman and Albert Kelly stand in front of a new car in 1935.

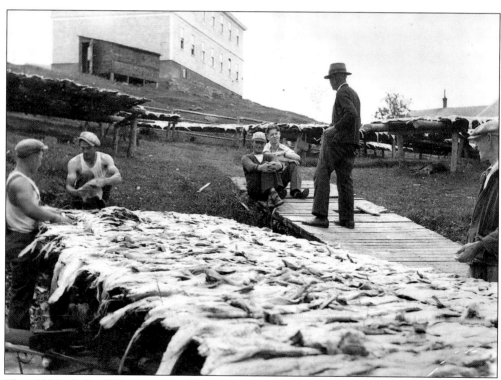

The old Maple Leaf Theatre is in the background of this photograph of drying pollock in the summer of 1935.

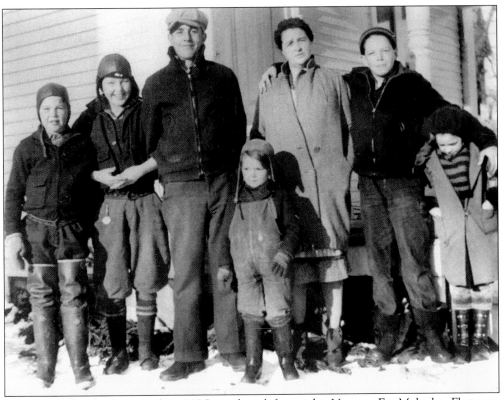

Posing for a family photograph in 1935 are, from left to right, Vernon, Ep, Malcolm, Florence, Ruby, Stan, and Harriet Savage.

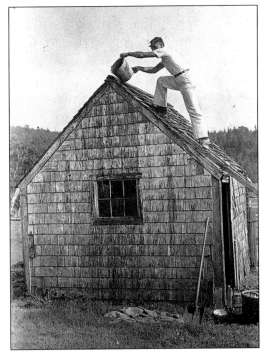

The old bucket brigade of Courtney Newman puts out a roof fire on a shed in 1935.

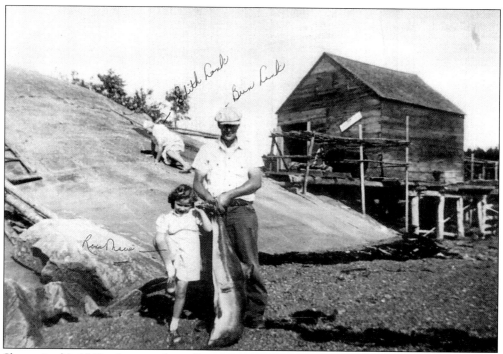

Shown in this 1940s photograph are Rose Marie and Ben Lank, in the foreground with a shark, and Edith Lank, behind them.

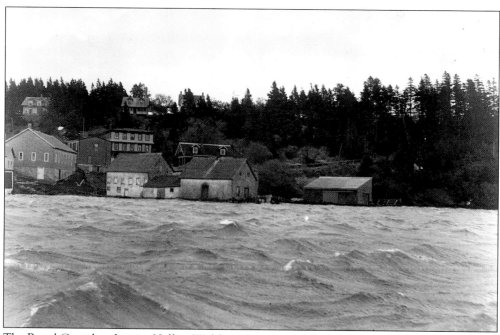

The Royal Canadian Legion Hall in Welshpool can be seen behind the rough sea waters in this 1940s photograph.

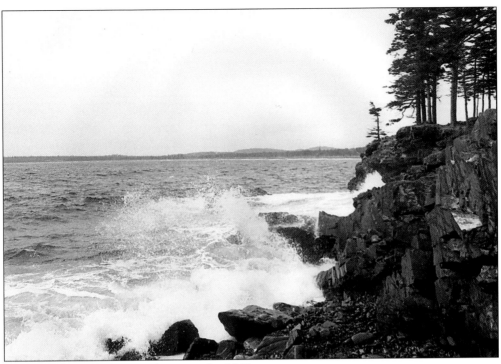

A Herring Cove seascape is shown in the 1940s.

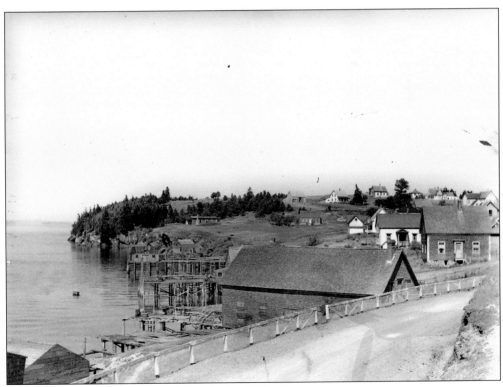

The Pollock Cove wharves are shown in the 1950s.

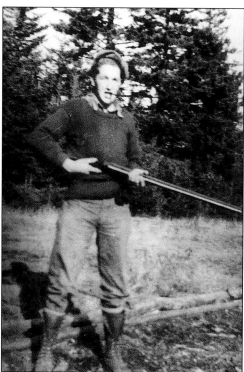

Ep Savage is out hunting birds in the autumn of 1950. He was a very well-liked member of the community. A war hero, he joined the Royal Canadian Air Force soon after the outbreak of World War II in Europe and served in England, where he met and married Doreen Wilkenson of the Royal Air Force.

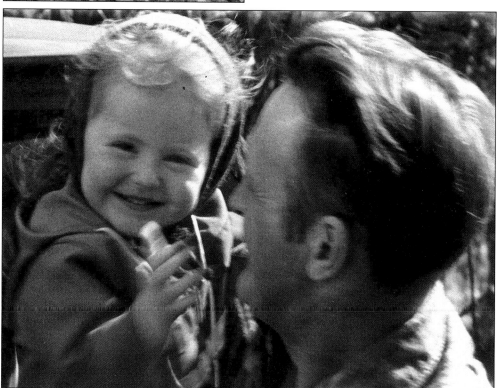

John Newman is pictured with his young daughter c. 1950.

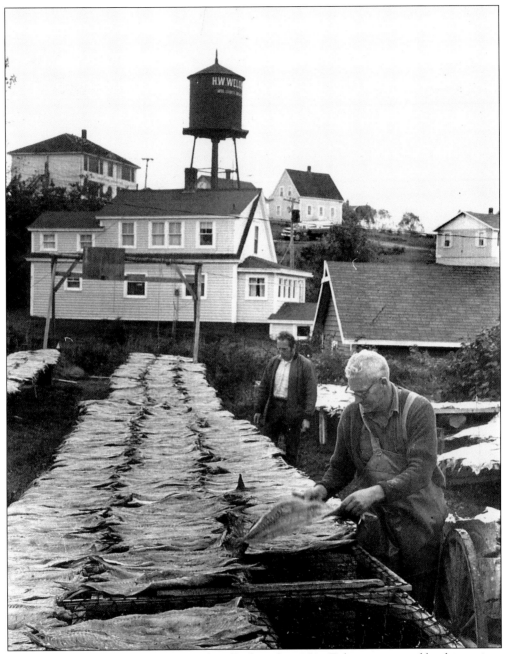

Burnham Lank and Donald Jackson salt pollock in the 1950s. Fish are preserved by this ancient process. They are dried to remove the moisture that is necessary for spoilage organisms, and they are salted to draw out more moisture and to drive away bacteria, which are repelled by salt.

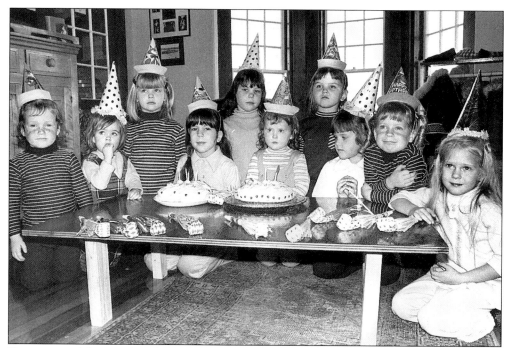

Youngsters celebrate a friend's birthday at this party held at the Campobello Public Library in the 1950s.

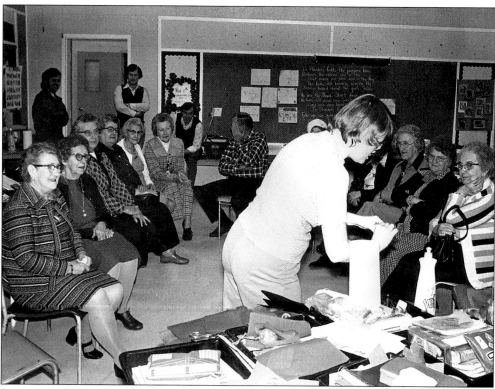

This meeting took place at the Wilson's Beach School during the 1950s.

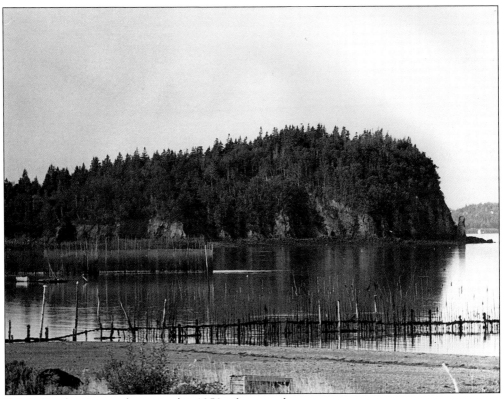

Friar's Head weirs are shown in this 1950s photograph.

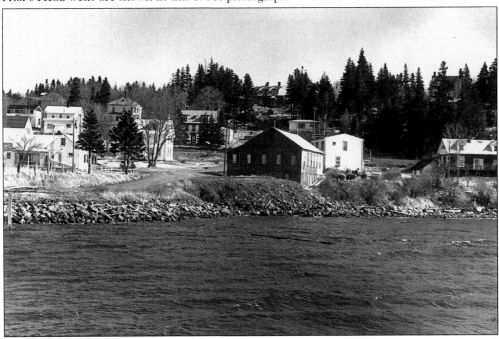

Shown, from left to right, are the Parker House, the Wendy Mitchell House, the Clive Mitchell House, and the Royal Canadian Legion Hall.

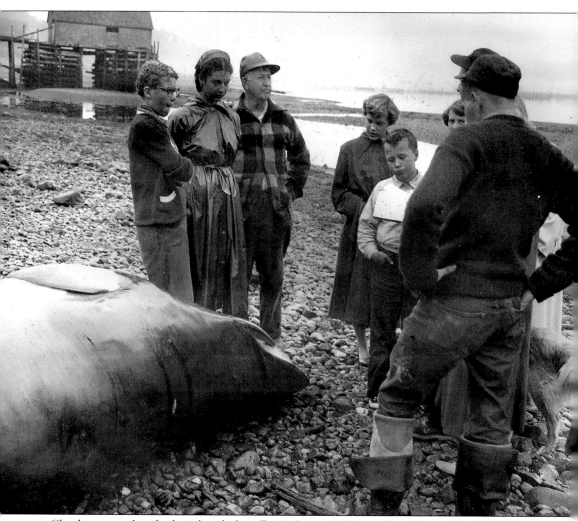

Checking out a beached minke whale at Friar's Bay in 1952 are, from left to right, Hilda Chute, Joyce Morrell, Wayne Morrell, Mary Chute, two unidentified persons, and Bud Ellingham. This spot is near where the present Friar's Bay Restaurant is located.

Shown on the wharf at Wilson's Beach breakwater in the 1950s are, from left to right, Blair Stanley, Garth Fitzgerald, and an unidentified person.

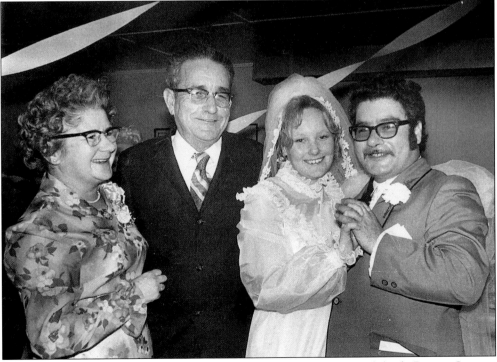

Celebrating at the wedding reception are, from left to right, Jean, Saul, bride Bonnie Simons, and bridegroom Louie Savage.

Harriet Parker is shown with her dog
Wendell in the 1960s.

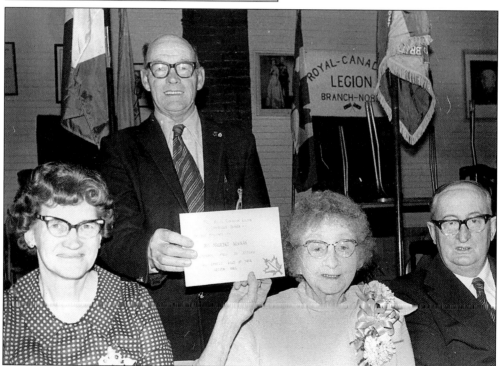

This 1960s photograph shows, from left to right, Hilda Brown, E. Mallock, M. Brown, and
W. Brown at the Royal Canadian Legion Hall.

Nelleke Calder had this portrait photograph taken in the 1960s.

The Savage children play and pose on one of their favorite treasures: the old anchor in their front yard. This photograph was taken in the 1960s.

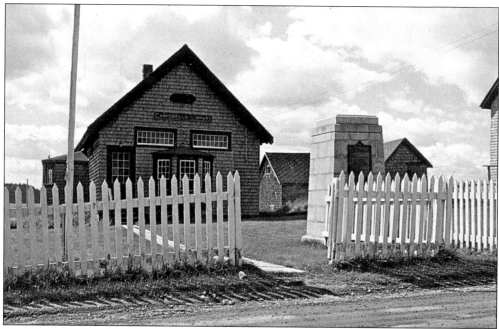

The Campobello Public Library and Museum is pictured in the late 1940s. The FDR Memorial can be seen on the right side of the photograph behind the picket fence. The Roosevelts had a strong relationship with the library; Franklin Roosevelt served on the Library Board in 1916 and, later, his son Franklin Delano Roosevelt Jr. was an honorary member of the board.

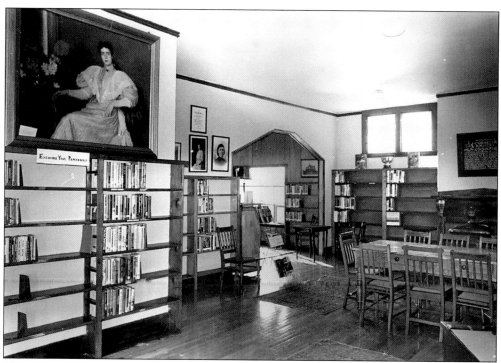

This 1960s photograph shows the interior of the Campobello Public Library and Museum.

Five

SCHOOL DAYS

The Owens family was made up of very well-educated members. All of the children had tutors, and many of the young sons went to England for more advanced education. By contrast, most of the local residents were self-taught until the late 1800s.

Formal elementary schools emerged in the late 19th century. In 1940, a high school was constructed on the island. Prior to that time, students had to take a ferry to Eastport, Maine, or board with families or friends in St. Stephen to attend high school. Since the 1940s, a comprehensive educational program has been available to all of Campobello Island's young people.

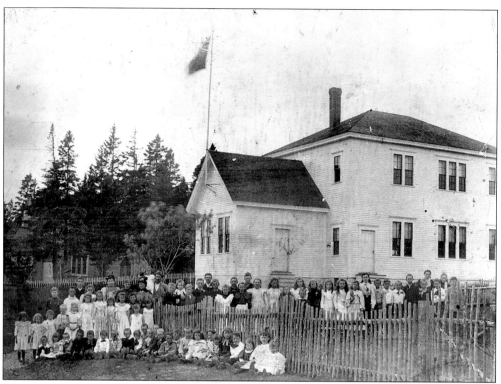

These students are shown at the Welshpool School during the 1890s.

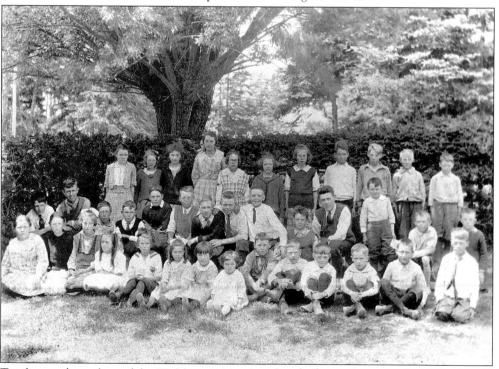

Teachers and members of the Welshpool School student body are shown in the 1890s.

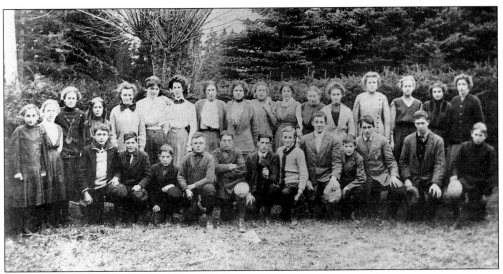

Students and faculty of the Welshpool School are pictured in this 1891 photograph.

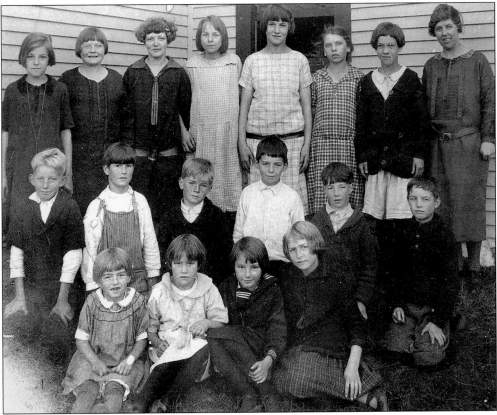

Students of the North Road School are, from left to right, as follows: (front row) Velma Calder, Eleanor Phinney, Anna Calder, and Alma Lank; (middle row) Chester Chute, Ernest Phinney, Clifford Calder, Arthur Calder, Godfrey Mitchell, and Alvin Chute; (back row) Blanche Calder, Eunice Thurber, Alice Corey, Bertha Lank, Dorothy Lank, Allison Mitchell, Elizabeth Lank, and Hazel Calder. The photograph dates from 1925.

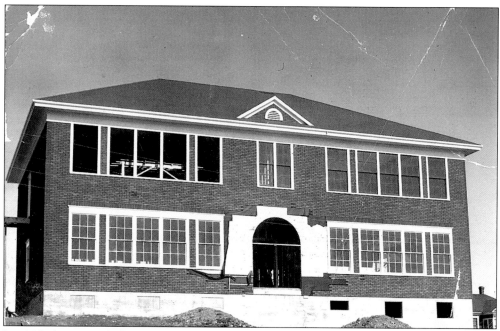

In 1940, the Campobello Consolidated School (high school) was built at Wilson's Beach. This ended the need for students to leave the island to obtain their high school education.

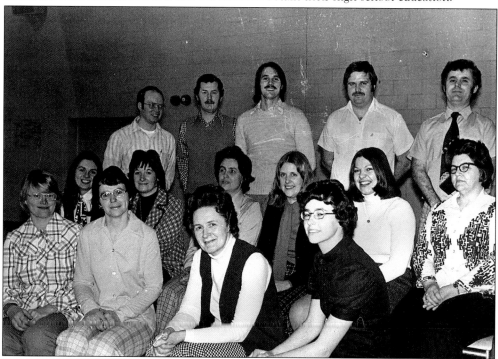

Faculty members at the Wilson's Beach School are, from left to right, as follows: (front row) M. Calder, G. Newman, R. Mathews, and unidentified; (middle row) unidentified, S. Goving, J. Lord, two unidentified persons, and M. Mallock; (back row) R. Stephenson, ? McCarthy, unidentified, ? Prince, and R. Estrebrooks. The photograph dates from the 1950s.

In 1954, these children were the students of Welshpool School teacher Joan Lord .

Two of Joan Lord's students are shown at the Welshpool School in 1954.

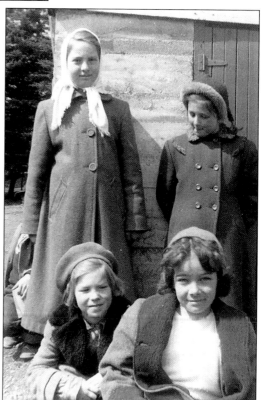

These four girls were members of Joan Lord's 1954 class.

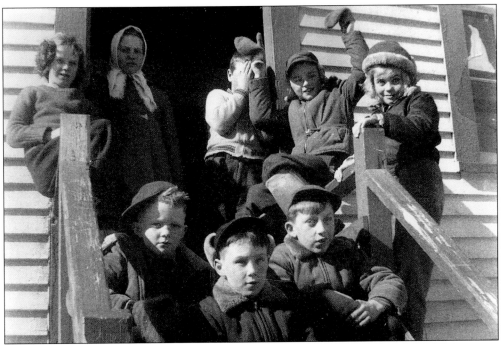

These Welshpool School classmates are shown in 1954.

These youngsters were also students in 1955.

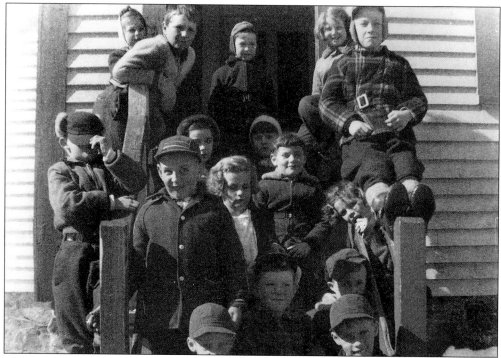

Members of Joan Lord's class are shown at the Welshpool School in 1955.

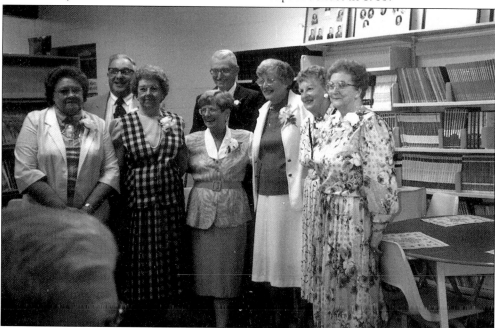

In 1944, the new Campobello Consolidated School held its first high school graduation with 11 students in the graduating class. Celebrating their 50th reunion are members of this first class, from left to right, Lillian Chute Corey, Darrell Chute, Marjorie Calder Lank, Elizabeth Mathews Jackson, Donald Thurber, Mina Corey, Louisa Alexander Robinson, and Beverly Daggett Robbins.

Six

THE ROOSEVELTS

During the summer of 1883, James and Sara Roosevelt and their infant son, Franklin Delano Roosevelt, vacationed at the recently built Ty'n-y-Coed Hotel on Campobello Island. The Roosevelts enjoyed Campobello Island so much that they purchased a parcel of land with a partially completed cottage. By the summer of 1885, the cottage was completed and the Roosevelts became members of the permanent summer colony.

Young Franklin Roosevelt loved hiking along the trails and cliffs of the island, canoeing on Lake Glenseveren, and golfing at the Campobello Golf Club. In 1900, at age 18, he was already showing his leadership qualities as a member of the golf club's governing committee. That August, he won the club's golf tournament.

After Franklin and Eleanor Roosevelt were married, they spent their summers on the island. The cottage that became known as the Roosevelt Cottage was completed in 1894 for Mrs. Hartman Kuhn of Boston and was just next door to James and Sara Roosevelt's cottage. Kuhn was fond of her neighbours and stipulated in her will that her cottage be sold to the family for a nominal fee and given to Franklin and Eleanor Roosevelt. James and Sara Roosevelt's cottage was unfortunately torn down in 1951, several years after Sara's death.

Franklin Roosevelt spent summers on the island from 1905 to 1921. During those years he introduced his growing family to the adventures he enjoyed, such as sailing on Passamaqouddy Bay. As his political career and responsibilities grew, his visits to Campobello Island were limited to a few days at a time. In 1920, he became the Democratic party's vice-presidential candidate; however, that November, the ticket was defeated. He then turned his full energy towards his business career as the New York office's vice president of Fidelity and Deposit Company of Maryland. In the summer of 1921, he was stricken with polio. Four Welshpool residents—Harry Mitchell, Erlan Cline, Leslie Gough, and Ray Finch—carried the stricken man by stretcher to the boat that took him to Eastport, Maine, where he connected with train service to New York.

President Roosevelt returned briefly in 1933, 1936, and 1939 to his beloved island. Eleanor Roosevelt returned on several occasions, once with son Elliot Roosevelt, on August 1, 1947, for the dedication of the FDR memorial at the Campobello Public Library and Museum, and again in August 1962 for the dedication of the Franklin Delano Roosevelt Memorial Bridge, linking Campobello Island with Lubec, Maine. She died three months later at age 78.

During the late 1950s, Dore Schary's stage play *Sunrise at Campobello* was a tremendous success. It was followed by Warner Brothers Studio's 1960 movie, staring Greer Garson and Ralph Bellamy. These productions have introduced Campobello Island to millions who have never visited, and have sparked fond memories for local residents and members of the summer colony.

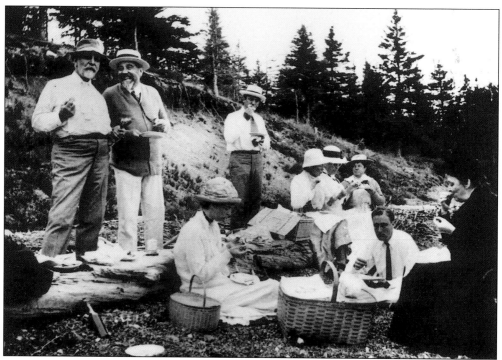

Enjoying a picnic with friends are, from left to right in the foreground, Eleanor, Franklin, and Sara Roosevelt. The friends partaking in this event on Campobello Island during the summer of 1906 are unidentified.

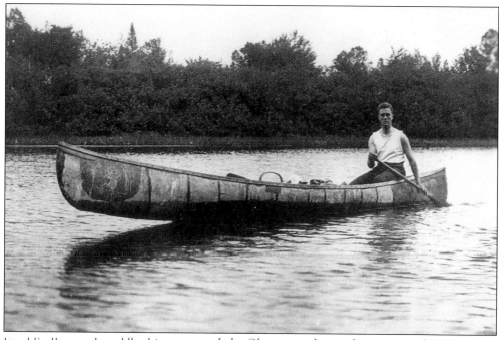

Franklin Roosevelt paddles his canoe on Lake Glensevern during the summer of 1907.

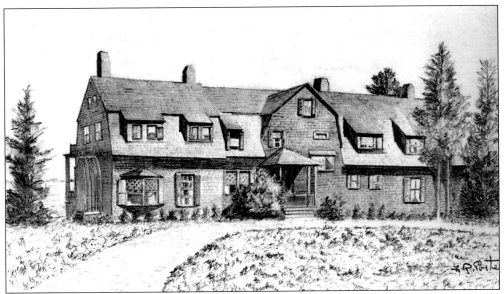

During the 1920s, Frances Porter created this line drawing of the Roosevelt cottage. The cottage was built between 1893 and 1894 by Mrs. Hartman Kuhn of Boston and was designed by noted Boston architect Willard T. Sears. Kuhn provided in her will that the cottage be made available to the James Roosevelts for a mere $5,000 dollars so that they in turn could give it to young Franklin and Eleanor Roosevelt.

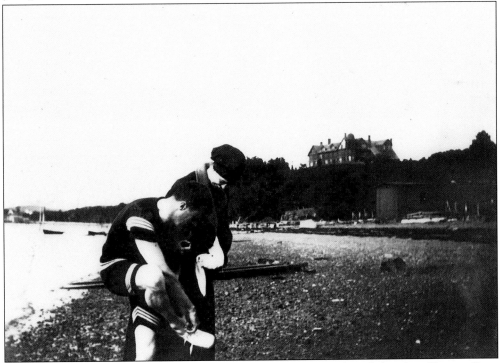

Franklin and Eleanor Roosevelt are shown on the long pebble and sandy beach at Herring Cove after taking a dip in the refreshing waters of Passamaquoddy Bay. The beach was a short walking distance from the cottage.

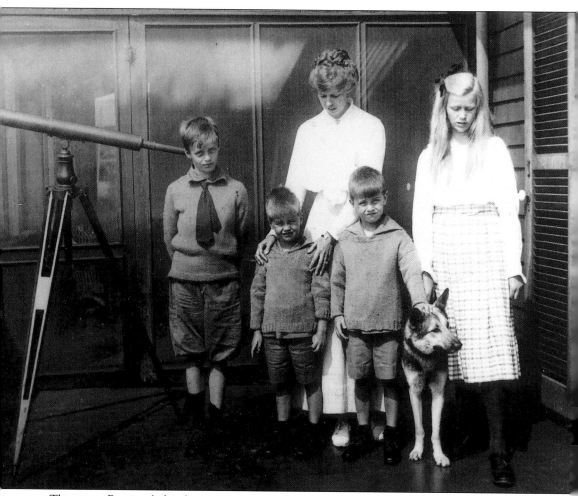

The young Roosevelt family enjoys a fine summer day in 1920 at the cottage. Eleanor Roosevelt stands behind her children, from left to right, Elliot, Franklin Delano Jr., John, and Anna. With them is their dog Chief.

Franklin Roosevelt sits on the front lawn of the Campobello cottage during the summer of 1920. That summer, he had received his party's vice-presidential nomination and may well have been writing some political strategy notes for the coming fall campaign.

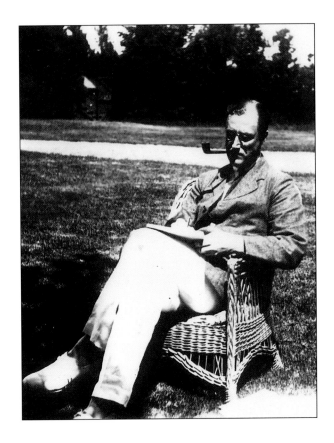

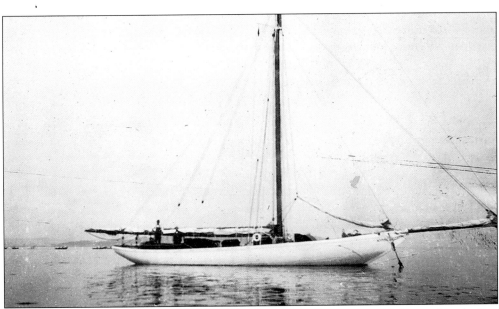

Roosevelt's passion for sailing was often met by day sails on Passamaquoddy Bay and in the Bay of Fundy on the *Half Moon*. This ship is shown on a mooring *c.* 1920.

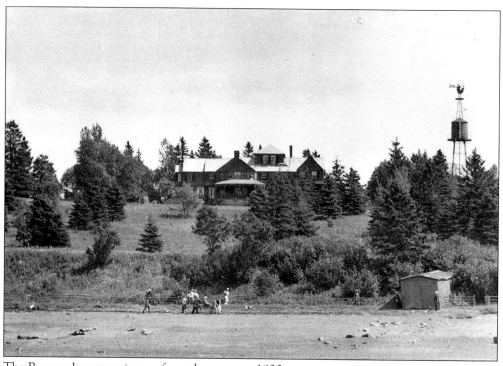

The Roosevelt cottage is seen from the water c. 1920.

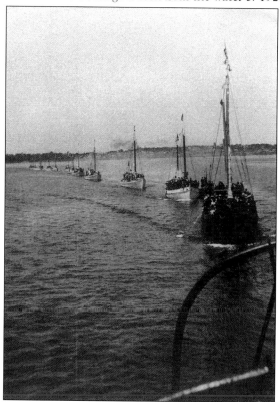

The Connors fleet welcomes Franklin Roosevelt home to Campobello as he sails in on the *Amberjack II* on June 24, 1933. This marked Roosevelt's first return to the island since being stricken with polio in 1921, as well as his first visit as the newly elected president.

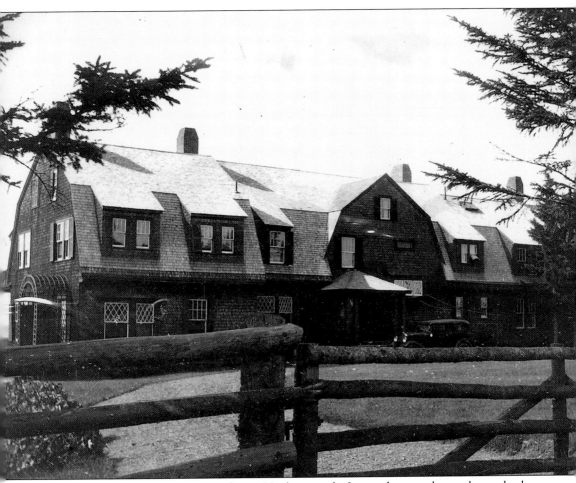

The Roosevelt cottage is shown in this 1933 photograph. It was decorated to welcome back, after an absence of nearly 12 years, the newly elected U.S. president.

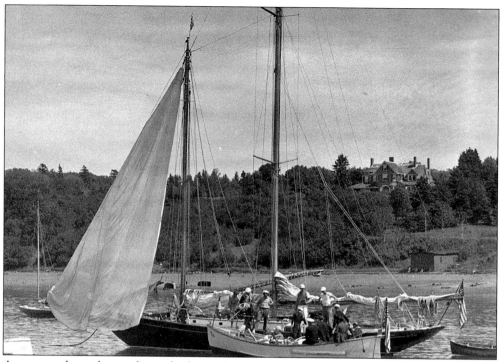

A navy tender is shown alongside the *Amberjack II*, docked at Campobello Island on June 24, 1933. The navy provided the president with an escort on his sailing trip to the island.

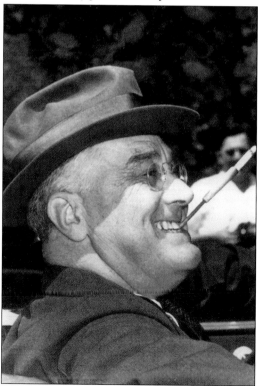

Franklin Roosevelt strikes his classic pose in April 1939. A few months later, he would make his final visit to the island.

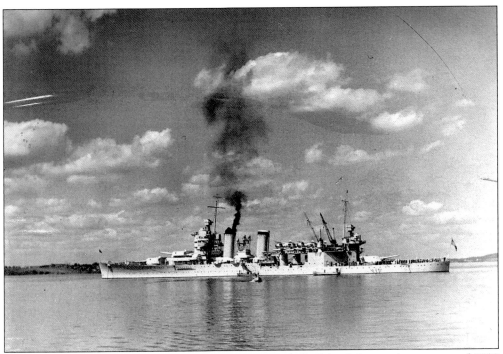

Roosevelt arrived for a brief and final visit to Campobello Island during the summer of 1939 aboard the USS *Tuscaloosa*.

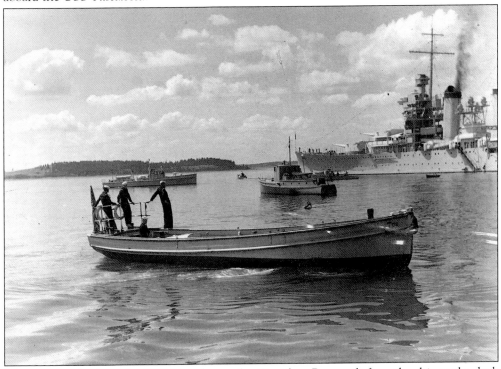

The navy tender from the USS *Tuscaloosa* takes President Roosevelt from the ship to the dock near his cottage.

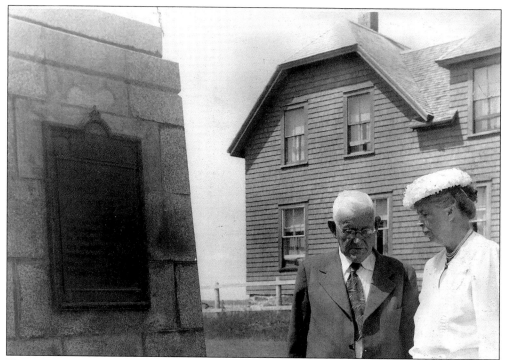

Eleanor Roosevelt and John F. Calder attended the dedication of the FDR Memorial on the Campobello Public Library and Museum grounds on August 1, 1947. Eleanor's son Elliot and Franklin's dog Fala accompanied her for this special commemoration. The Roosevelts had a long and close relationship with the library. In 1916, Franklin Roosevelt had served on the library board.

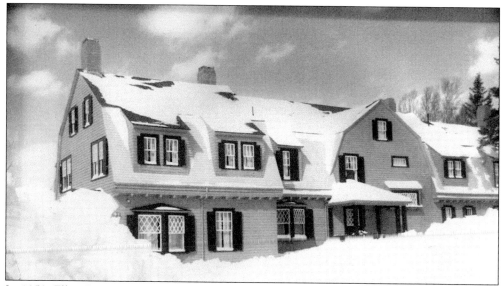

In 1952, Elliot Roosevelt, with his mother's consent, sold the cottage to the Hammer family of New York. The Hammers restored the cottage, adding Roosevelt memorabilia as well as installing electricity and a telephone. The family made the cottage available to Eleanor Roosevelt when she visited Campobello Island.

Warner Brothers Studio planned to start on-location production of *Sunrise at Campobello* in early June 1960. This letter is from the studio to Mrs. Wayne Morrell, owner of the Owen House, confirming reservations for members of the cast.

Schary Productions, Inc.
454 NORTH RODEO DRIVE · BEVERLY HILLS · CALIF.
CRestview 5-4335 CRestview 5-4336

April 28, 1960

Mrs. Wayne Morrell
Welchpool
Campobello Island
New Brunswick, Canada.

Dear Mrs. Morrell:

Victor Hammer was kind enough to write to me and give me a description of the accomodations you would have available for several members of our company. The accomodations are fine, but it won't be necessary to use the third floor.

The company itself will be there around June 6th, but I will be making a trip up there a week prior to that date and if there are any additional questions I can speak to you at that time.

Please don't be concerned about the insurance problem. I'm sure that you carry general liability insurance and my people are all covered by Workmen's Compensation Insurance.

Unless I hear from you otherwise, may I assume that I can plan on the available rooms on your first two floors. If there are any questions that you would like to have answered prior to my arrival, please don't hesitate to write to me at the above address.

Thank you for your cooperation and I'd like to say that I am looking forward to meeting you.

Sincerely,

JOEL FREEMAN
Production Supervisor

JF:pma

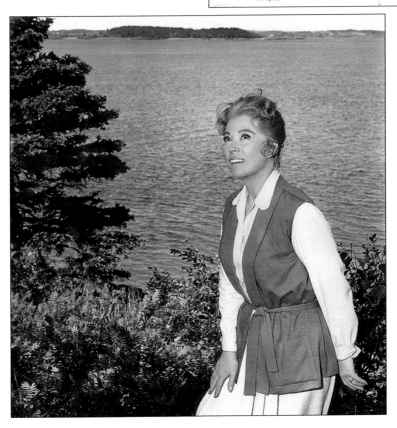

Greer Garson played the role of Eleanor Roosevelt in the film. Garson is pictured at Deer Point on the grounds of the Owen House, where she was staying during the shooting of the film.

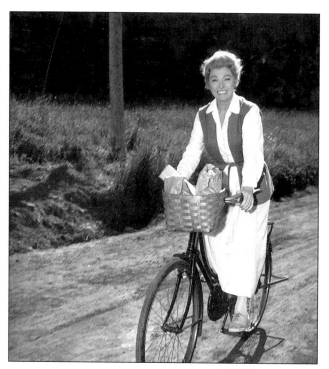

A studio still photographer shot this promotional photograph of Greer Garson in a scene from the film *Sunrise at Campobello* in June 1960.

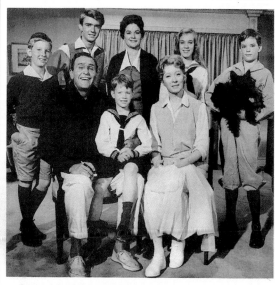

The dramatic, heart-warming story of Franklin D. Roosevelt as a young father, Dore Schary's Broadway hit and about to be Warner Bros. film, "Sunrise at Campobello," got under way at the Studio. Here is F.D.R. played by Ralph Bellamy, and Family -- left to right, standing, Robin Warga, as Franklin, Jr.; Tim Considine, James; Jean Hagen, Miss Lelland; Zina Bethune, Anna; Pat Close, Elliot, with Lady as the Scottie, "Duffy," and, seated, Mr. Bellamy, Franklin Delano Roosevelt; Tommy Carty, Johnny, and Greer Garson, Eleanor.

This is one of the studio's news releases showing the cast prior to filming.

A thank-you letter from Greer Garson to Mrs. Wayne Morrell was part of a friendship between the two women that began during filming and lasted many years.

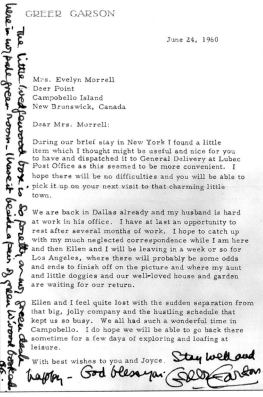

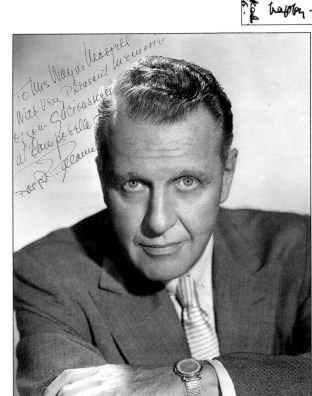

Ralph Bellamy headed up the cast, playing the role of Franklin Roosevelt. As thanks for the hospitality that Mrs. Morrell had extended to him while he was on the island, Bellamy sent her this autographed photograph.

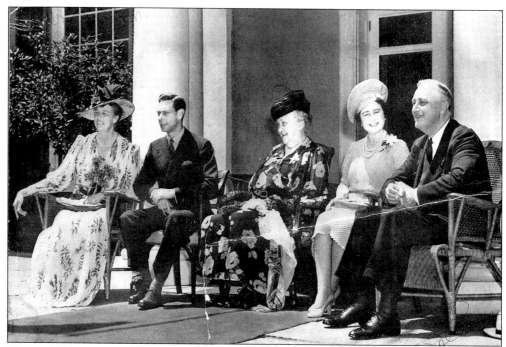

This c. 1939 photograph was given to members of the cast of *Sunrise at Campobello* in 1960. Shown, from left to right, are Eleanor Roosevelt, King George VI of England, Sara Roosevelt, the Queen Mother, and FDR.

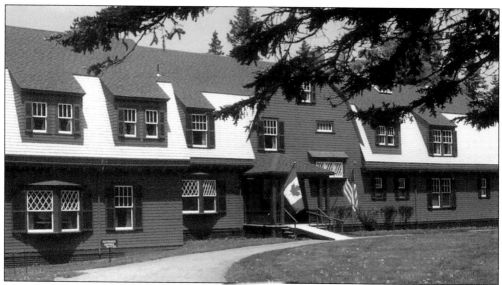

The Roosevelt International Park was established on January 22, 1964, by an international agreement signed by Prime Minister Lester B. Pearson and U.S. Pres. Lyndon B. Johnson. On August 20, 1964, the first ladies of the two countries opened the only international park in the world as a unique memorial to the close relationship between the people of the two nations. Both governments wished to honour the role that Franklin Delano Roosevelt had played in their mutual histories, as well as the special relationship that he had had with his beloved island.

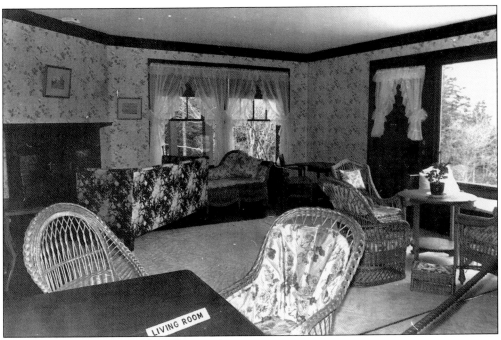

Shown is the living room of the Roosevelt cottage.

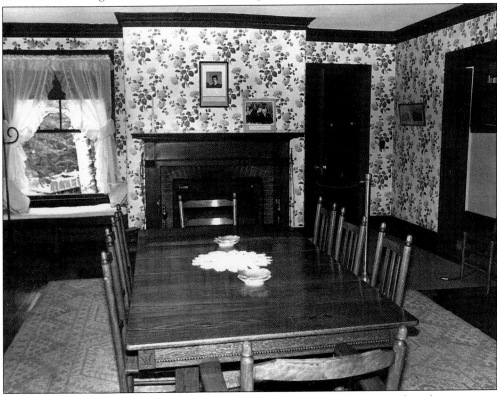

The dining room, like all the rooms of the Roosevelt cottage, is maintained in the exact way the house was furnished when the young Roosevelt family spent summers on the island.

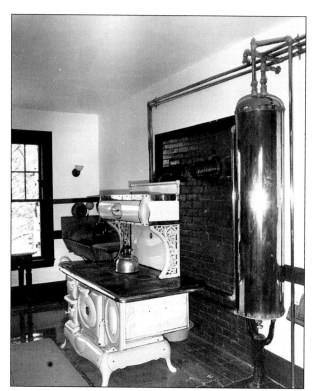

This photograph of the kitchen showcases the wood stove and the copper water tank, which was gravity fed from the well since the cottage had no electricity.

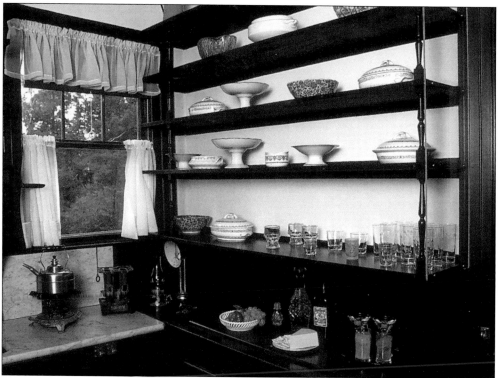

The butler's pantry housed the service ware used for meals.

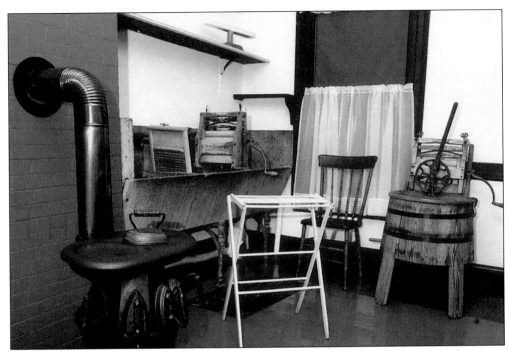

The laundry room of the cottage was a busy work area during the summers when the young Roosevelt family was there. All wash was done by hand.

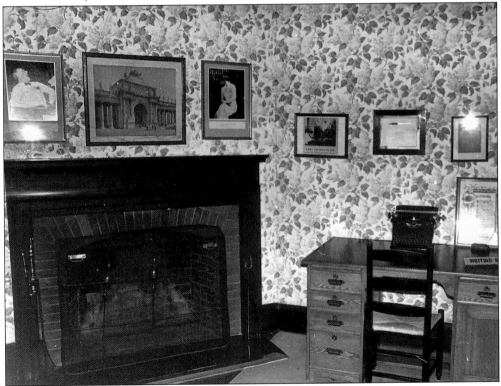

The study provided a quiet place for the Roosevelts to do research or paperwork.

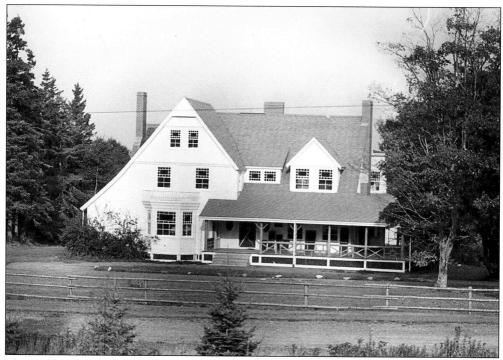

The Hubbard cottage, next door to the Roosevelt cottage, was designed and built in 1892 by Mr. Hubbard of Boston, a successful insurance broker. The Roosevelt Campobello International Park Commission acquired it, along with several other neighbouring cottages, for inclusion into the park's property. The Hubbard cottage is also open to the public.

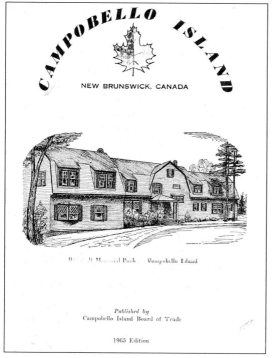

In 1965, the Campobello Island Board of Trade used this cover on their brochure to promote summer tourism to the island. The year marked the first full season of operation since the park opened, on August 20, 1964.

Seven

THE FERRY CONNECTIONS

Between 1881 and 1915, when the Campobello Land Company was developing a summer colony for wealthy families, good connecting ferry service to the island was a critical ingredient to attracting the desired clientele. The ferry services met the need. Ferry service continued to be a necessity for residents, members of the summer colony, and visitors until the Roosevelt Memorial Bridge linking the island to Lubec, Maine, at the Narrows went into operation in August 1962.

Prior to the bridge, such basic activities as shopping were dependent upon a ferry. Until the opening of the Campobello Consolidated School in 1940, most high school students from the island traveled by ferry daily during the school year to Eastport, Maine, to attend high school.

Ferry service between Lubec, Eastport, Deer Island, Grand Manan, Campobello Island, and St. Andrews provided needed transportation throughout the region. Ferry service remains a viable mode of transportation and allows one to enjoy a glimpse of the way life used to be.

PASSAMAQUODDY STEAM FERRY.

Between Lubec, Eastport, North Lubec and Campobello

1902 FALL and WINTER Arrangement, 1903

(STANDARD TIME.)

Beginning Monday, Oct. 20, 1902, Steamers **EASTPORT**, **LUBEC** or **CAMPOBELLO** will make regular trips daily, (Sundays excepted) as follows:

Leave Lubec for Eastport:		Leave Eastport for Lubec:	
7.15 A. M., via	North Lubec	8.00 A. M., via	North Lubec
9.00	Campobello	10.00	North Lubec
11.00	Campobello	12.00 M.	Campobello
1.15 P. M.	North Lubec	2.00 P. M.	North Lubec
2.45	Campobello	3.30	North Lubec
4.20	Campobello	5.00	Campobello
Fare, Round Trip, same day, 25 cents.		**Children under 12 years, 10 cents.**	

The above Passamaquoddy Steam Ferry schedule is for the fall and winter 1902–1903 between Campobello Island and North Lubec. This company ran ferry service between Lubec, Eastport, North Lubec, and Campobello. Round-trip adult fare was 25¢ and 10¢ for children aged 12 and under.

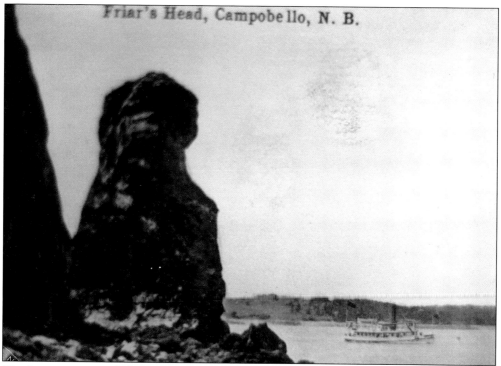

The ferry connecting Lubec, Campobello, and Eastport plies the waters out past Friar's Head in Passamaquoddy Bay in the 1920s.

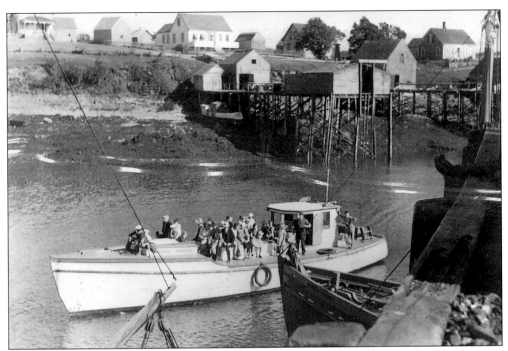

The boat to Eastport leaves Campobello with folks going over to the mainland to do some shopping in the 1930s.

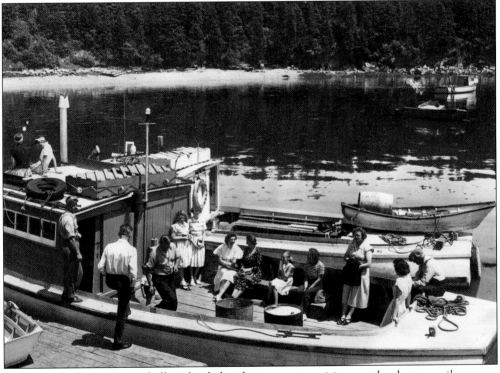

The ferry docked at Campobello is loaded with passengers waiting to take the two-mile voyage across Passamaquoddy Bay to Eastport, Maine, on a summer day in the 1950s.

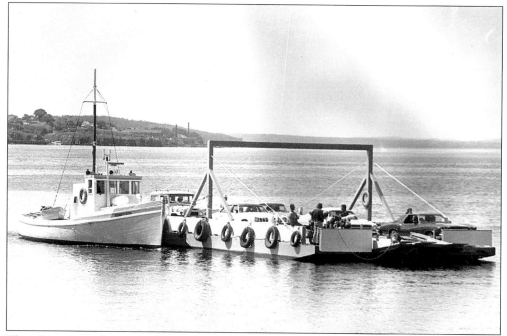

This photograph depicts car ferry service from Campobello Island to Lubec, Maine, in 1960, just prior to the opening of the FDR Memorial Bridge. The bridge opened in August 1962, linking the two communities.

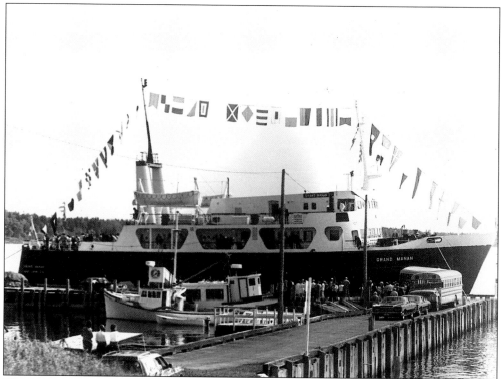

The Grand Manan ferry docks at Welshpool are shown in the early 1960s.

Eight

A SEAFARING LIFE

The tides have brought people, natural beauty, and abundance to this outer island in Passamaquoddy Bay. It should come as no great surprise that a life surrounded by the sea urges one to earn a living as a fisherman or mariner, or even simply to enjoy sailing as an avocation. Most families on Campobello are directly or indirectly involved in a seafaring life and have a great love and respect for the sea around them.

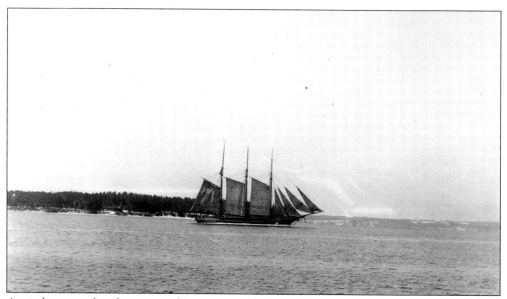

A windjammer plies the waters of Passamaquoddy Bay off Campobello Island during the 1920s.

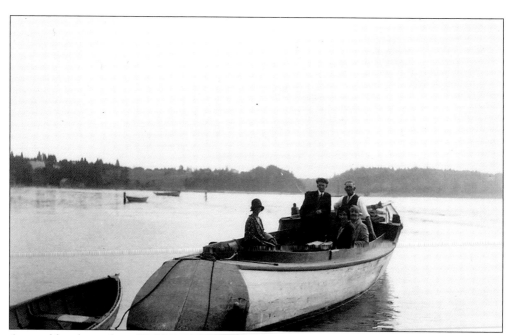

A vessel heads out from Welshpool for a summer cruise on Passamaquoddy Bay in the 1920s.

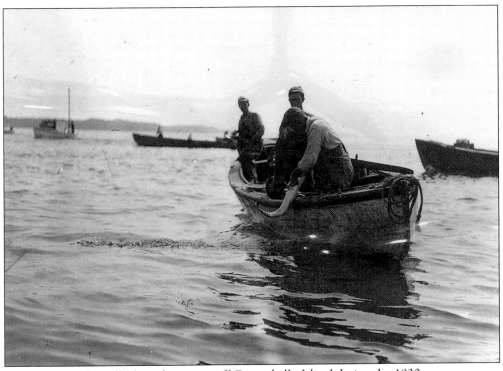

A group fishes for pollock in the waters off Campobello Island during the 1920s.

A good size pollock is taken on board in the 1920s.

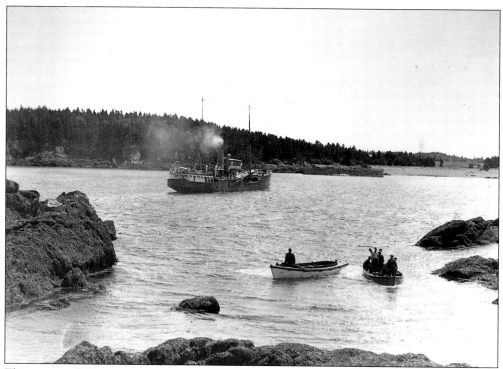

This group is fishing in Lighthouse Cove during the 1920s.

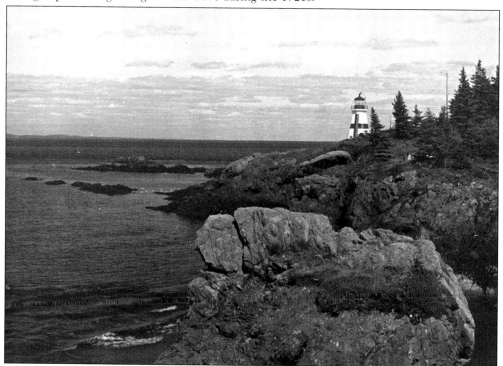

Besides providing a beacon to guide mariners off Campobello in the Bay of Fundy, the East Quoddy Head Harbour Light is the most photographed and painted light in New Brunswick.

These sailors enjoy a day sail out on Passamaquoddy Bay in the 1930s.

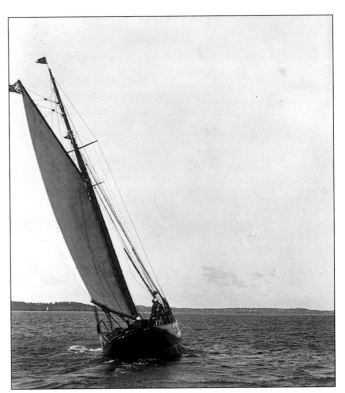

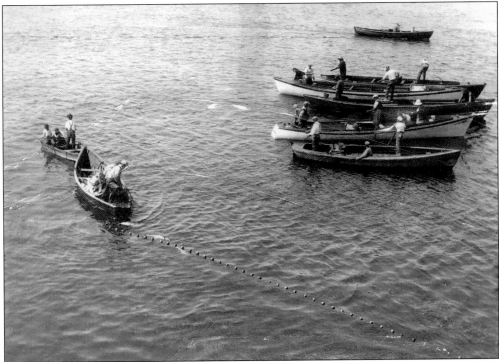

This photograph shows fishermen seining pollock at Windmill Point during the summer of 1935.

Courtney Newman captains a boat in Passamaquoddy Bay in the summer of 1935.

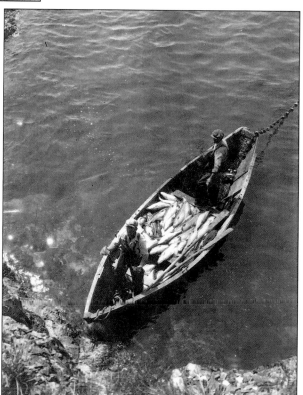

Quite a good day's catch fills this dory c. 1930.

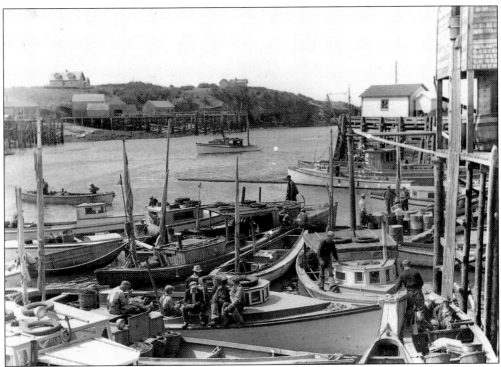

The fishing fleet is docked at Wilson's Beach in 1935.

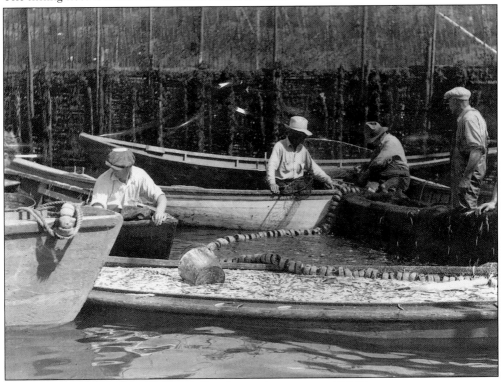

These fishermen are shown at Friar's Bay during the summer of 1935.

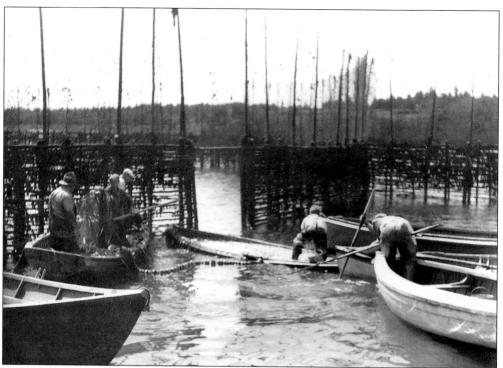

This 1935 photograph shows fishermen working a seining weir at Friar's Bay.

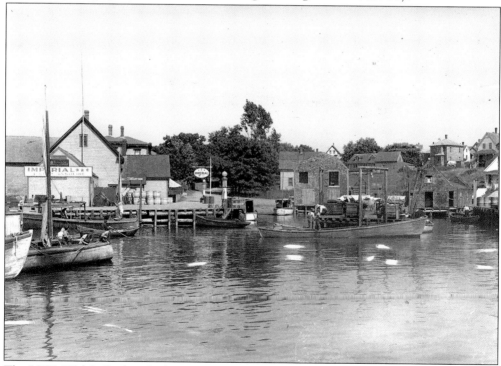

The H.W. Welch Sardine Packing Company at Jackson's Wharf can be seen in this vintage late-1940s photograph.

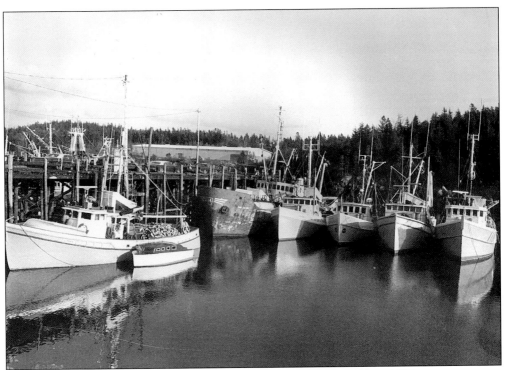

The fishing fleet is shown at Head Harbour, Wilson's Beach, in the late 1950s.

The *Glenwood* is seen at Welshpool in the 1950s.

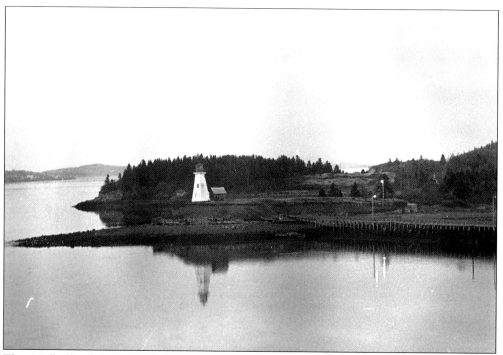

The Mulholland Point Lighthouse provides a safety beacon for mariners navigating at the Narrows.

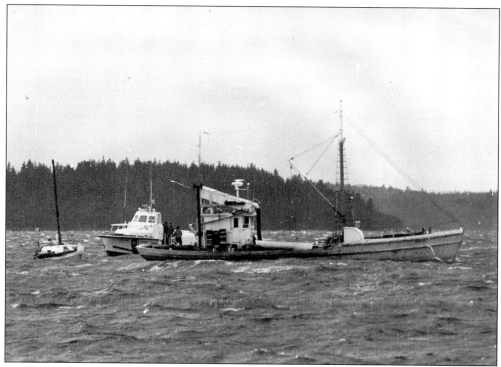

The U.S. Coast Guard checks out a sailboat that several people had been living on during a winter in the 1950s. Unfortunately, the Coast Guard found that all on board had perished.

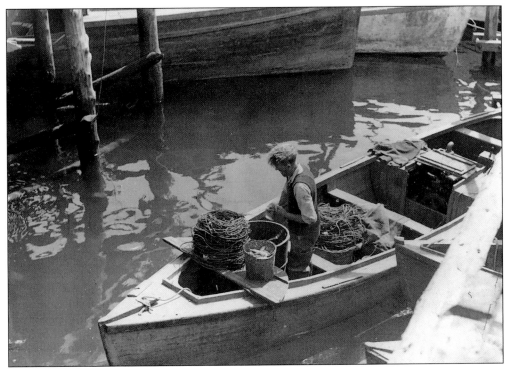

Asa "Ace" Brown baits up troll in the 1950s.

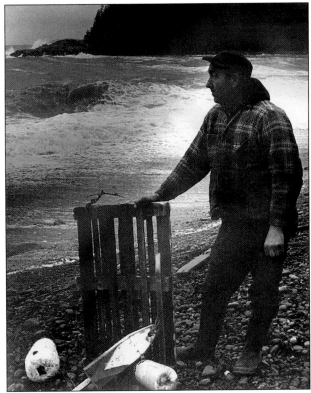

Sheldon Fletcher checks out a
lobster trap and some buoys on
Raccoon Beach in the 1960s.

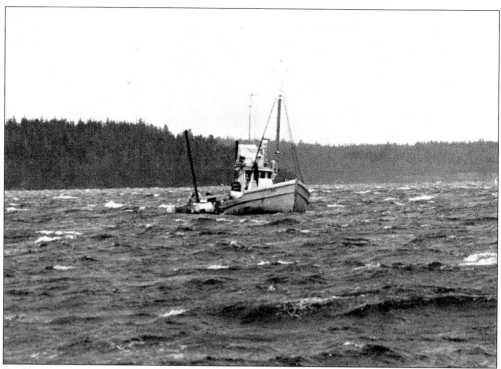

Sardines were an important fish to the economy of the region through the 1960s. This photograph was taken in the 1960s.

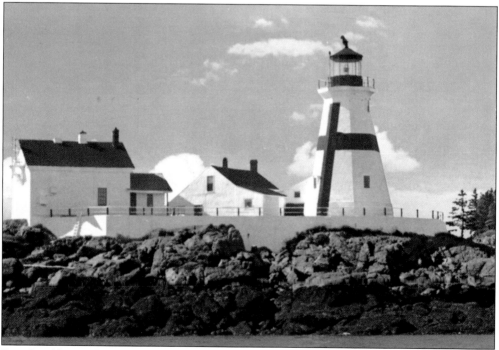

East Quoddy Head Harbour Light Station has been a beacon for mariners since 1828. The light is located at the farthest northeast tip of Campobello Island overlooking the Bay of Fundy.

Nine

PROUDLY THEY SERVED

There is no greater act of honour and bravery than serving one's country in battle. November 11, Remembrance Day, is held to honour and thank all those who have fought for the country's freedom.

World War I, the war to end all wars, unfortunately did not provide the peace that many Canadians fought for, but the ideals that they held remain as relevant today as then.

These brave sons of Campobello made the supreme sacrifice for their nation during World War I:

Pvt. Harry Tinker of Wilson's Beach—May 24, 1917
Pvt. Judson Emery Mitchell of Wilson's Beach—August 9, 1918
Pvt. Merrill Ray Lank of Wilson's Beach—September 28, 1918

The poet Joyce Kilmer, who died while serving in the U.S. Army in France in 1918, wrote this touching poem to express the physical and mental pain every soldier was suffering.

Prayer of a Soldier in France

My shoulders ache beneath my pack
(Lie easier, Cross upon His back.
I march with feet that burn and smart
(Tread Holy Feet, upon my heart).
Men shout at me who may not speak
(They scourged Thy back and smote Thy cheek).
I may not lift a hand to clear
My eyes of salty drops that sear.
(Then shall my fickle soul forget
Thy agony of Bloody Sweat?)
My rifle hand is stiff and numb
(From Thy Pierced palm red rivers come).
Lord, Thou didst suffer more for me
Than all the hosts of land and sea.
So let me render back again
This millionth of Thy gift. Amen.

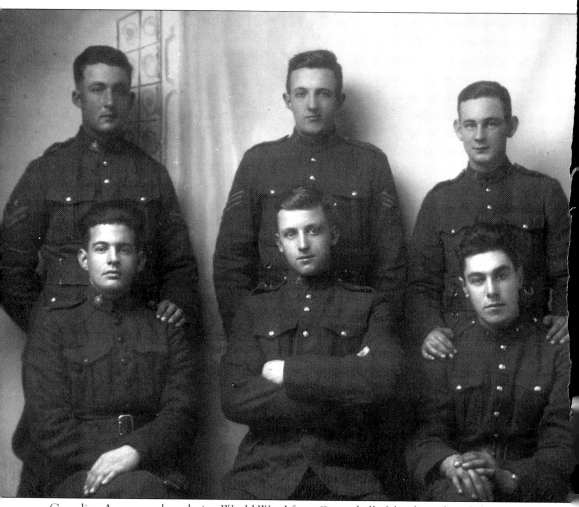

Canadian Army members during World War I from Campobello Island are, from left to right, as follows: (front row) Godfrey Parker, Wilford Alexander, and Edward Byron; (back row) Marvin Williams, Arthur Hickson, and Jack Newman. Not pictured are other sons of Campobello who made the supreme sacrifice while serving their country in France during World War I. Among them are Pvt. Harry Tinker, Pvt. Judson Emery Mitchell, and Pvt. Merrill Ray Lank, all of Wilson's Beach.

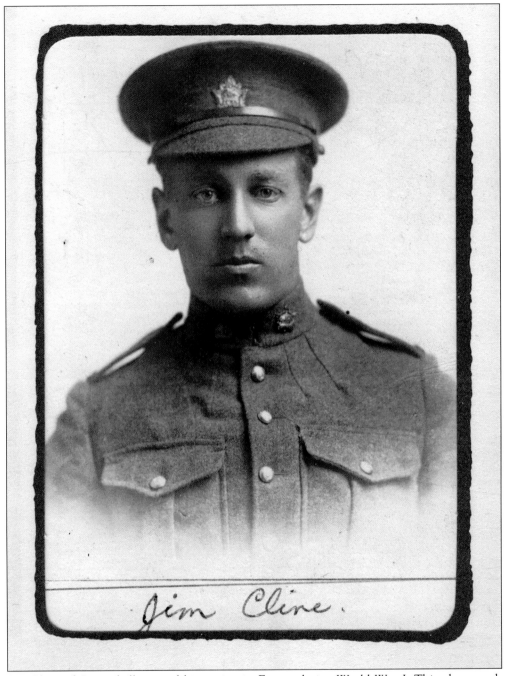

Jim Cline of Campobello served his nation in France during World War I. This photograph was taken c. 1916.

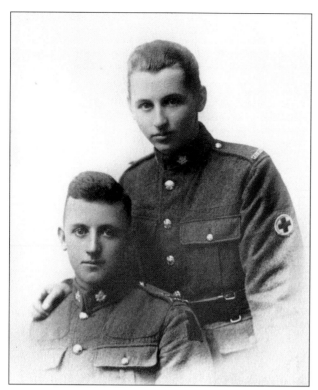

Wilford A. Alexander, seated, is shown with his brother John James Alexander. This photograph was taken when both were home on leave c. 1914. Upon returning from the war, John James Alexander entered the seminary and was ordained an Anglican priest.

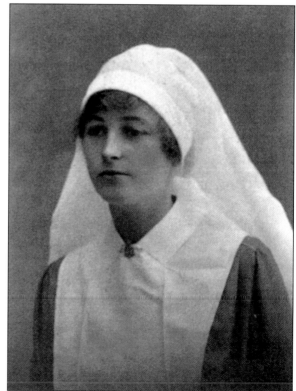

Alison Alexander served as a nurse on the front lines in France during World War I. There, she contracted influenza and might well have died if not for the medical attention she received from her fiancée, Dr. Stanley Bridges.

Frank Lank of North Road served in World War I with the "Fighting 26th" New Brunswick Battalion in France from 1914 to 1918.

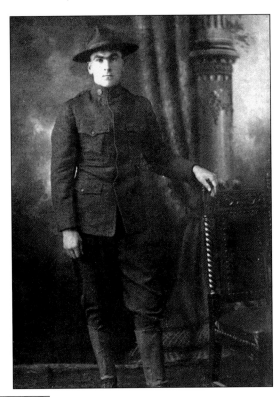

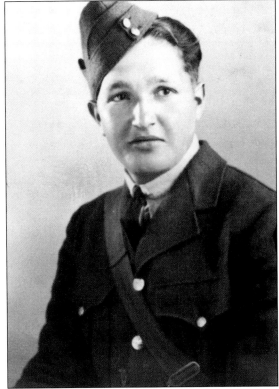

Aircraftsman Wallace Ethelbert "Ep" Savage enlisted in the Royal Canadian Air Force (RCAF) on September 19, 1939, just a little over two weeks after the Germans had marched into Poland and ignited World War II. He was the first to volunteer for service from Campobello Island.

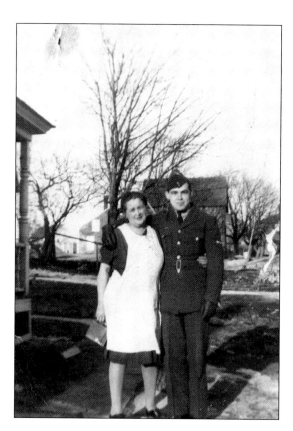

Ruby Savage is shown with her son Vernon "Jiggs" Savage, who was serving with the Royal Canadian Air Force Motorbike Division. Vernon Savage was home on leave when this 1940s photograph was taken.

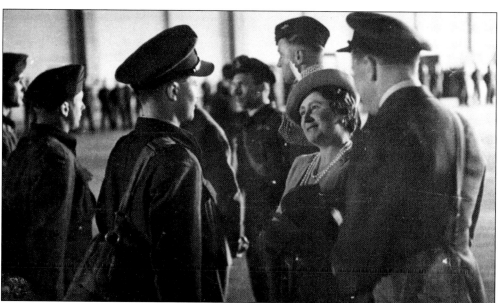

The Queen Mother and King George VI visit the Royal Canadian Air Force 419 "Moose" Squadron at its base in Lincolnshire, England. Aircraftsman Ep Savage served with this illustrious squadron. The 419th flew a total of 4,293 sorties and holds records for its heavy casualties.

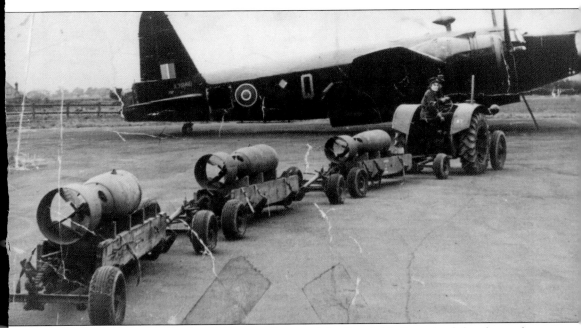

Leading Air Volunteer Doreen Wilkenson Savage of the Royal Air Force loads bombs on the flight line in 1940. Wilkenson married Ep Savage on September 19, 1942, at St. Mary's Church in Mildenhall, England.

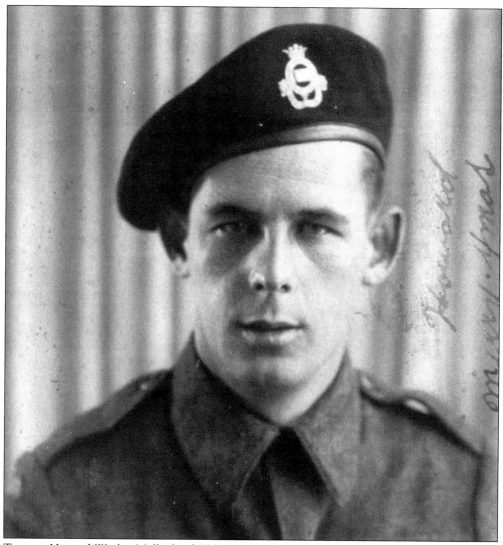

Trooper Howard Wesley Malloch of Wilson's Beach sacrificed his life in service of his nation on October 9, 1944. He served with the 8th Princess Louise's New Brunswick Hussars Royal Canadian Armoured Corps.

Pvt. Lawson Henry Searles of Campobello Island lost his life in service to his nation on July 8, 1944, at Normandy, France. He served with the North Shore New Brunswick Regiment Royal Canadian Infantry Corps.

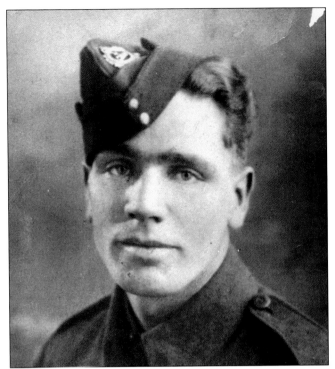

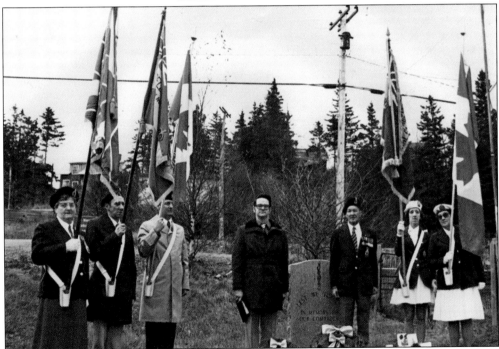

Honouring those who faithfully served their nation in time of war are, from left to right, L. Brown, P. Cline, Rev. A. Greene, W. Newman, G. Cline, and M. Mallock. The photograph was taken in front of the Royal Canadian Legion Hall in Welshpool on Remembrance Day, November 11, 1960.

As Queen of Canada, I congratulate the Royal
Canadian Legion on attaining its Golden Anniversary, and
I thank all the Members of the Legion for their kind
messages of renewed loyalty and allegiance sent to me on
this memorable occasion.

At this time my thoughts go particularly to the
veterans of the First World War. Since the end of that
War and the foundation of the Legion in 1925, they have
witnessed many changes in Canada and in the world. The
peace for which they fought and strove has been shattered
again and again, but the ideals which moved them remain
constant and are of equal importance today.

Que la vie pour tous les Membres de la Légion,
surtout dans cette année anniversaire, se garde agréable
et remplie des meilleures choses; et qu'ils maintiennent
leur haute tradition de service à travers le Canada.

Elizabeth R

Buckingham Palace.
November, 1975.

Queen Elizabeth penned a congratulatory letter to the Royal Canadian Legion on its
Golden Anniversary.

Ten

THE PASSAMAQUODDY DAM PROJECT

In the early 1920s, Dexter Cooper was recuperating from an appendix attack at his wife's family's cottage on Campobello Island. The Sturgises had owned their cottage for years, and Cooper and his bride had honeymooned there in 1912. A young engineer, Cooper started back on the road to recovery and began measuring and checking the great tides and visualizing how hydroelectric power could change the entire region's economy. He soon started discussing his vision with Franklin Delano Roosevelt, whose cottage was across the road.

In 1924, Cooper filed an application with the U.S. Federal Power Commission for a preliminary permit to construct the project on an international scale. Many years of political debate followed. A Canadian charter expired in 1929 and was not renewed because it was thought that the project would damage fishing. The 1929 market crash put a halt to it.

On November 14, 1934, Dexter Cooper was appointed by the U.S. Secretary of the Interior to head up the newly created Passamaquoddy Bay Power Commission; his friend, by then President Roosevelt, signed a special allocation of $7 million.

The project was up and running by July 4, 1935, and would give work to between 3,000 and 4,000 Works Progress Administration (WPA) workers. However, the U.S. Congress cut off funding for the project in 1936 and it was abandoned. In 1938, Dexter Cooper died without ever seeing his dream become a reality.

Dexter Cooper, a man with a dream to harness the tides of Passamaquoddy Bay and dramatically change the economy of the region, worked tirelessly from the early 1920s until his death in 1938 to make his vision a reality. Unfortunately, the politics of the time did not embrace Cooper's vision.

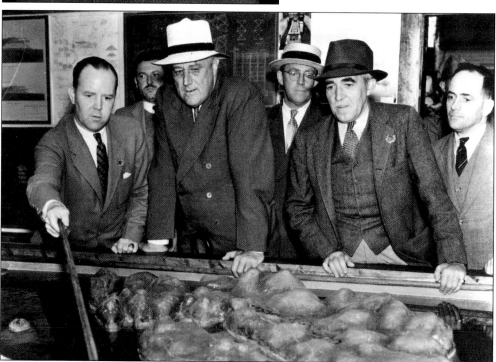

This 1936 photograph shows the president of the United States looking over the model of the Passamaquoddy Tidal Power Project at Quoddy Village in Eastport, Maine. Shown are, from left to right, Eastport (Maine) Mayor Roscoe Emery, Oscar Brown, Pres. Franklin Roosevelt, Maine Gov. Ralph Brewster, Dexter Cooper, and Lieutenant Colonel Flemming.

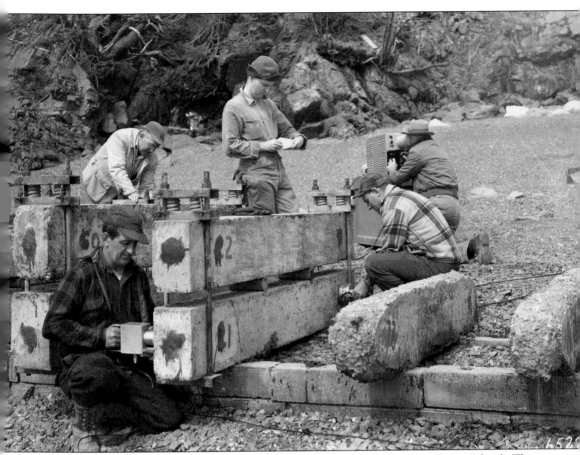

A Works Progress Administration crew tests cement for the project at Treats Island. The proposed dam that Dexter Cooper envisioned was to be built from Campobello Island to Deer Island.

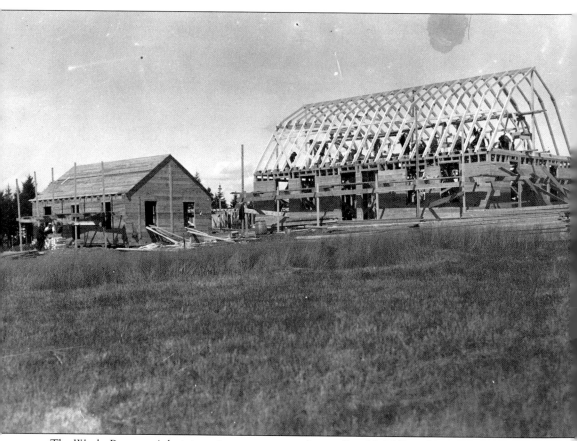

The Works Progress Administration crew came to live in Quoddy Village during its construction. This photograph shows Quoddy Village in 1935 as it was being built.

The Works Progress Administration workforce was a significant one for the Passamaquoddy Dam Project. As many as 4,000 workers came from all over the northeastern United States to live in the newly built Quoddy Village. This photograph dates from 1936.

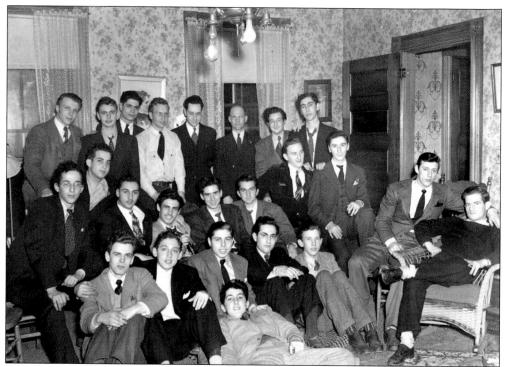

Members of the Works Progress Administration crew relax during an evening at the Quoddy Village housing facility in 1936.

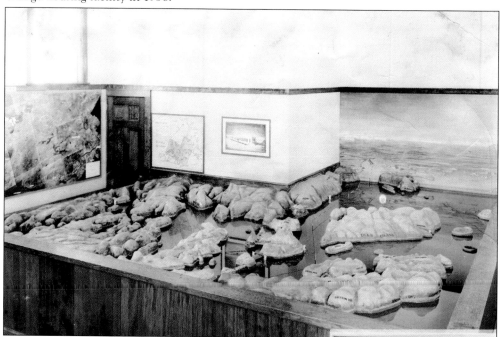

This July 21, 1936 photograph depicts the Passamaquoddy Tidal Power Project model. The project was cancelled in August 1936 when the U.S. Congress failed to appropriate funding for its continuance.

Eleven

WINTER DAYS

The days grow short once December dawns and, as the year draws to a close, driving snow and chilling winds are bound to arrive soon. Sometimes the surf pounds so hard against the beaches and cliffs that it seems all will be swept into the Bay of Fundy, but the storm simply leaves behind a glittering wonderland as it moves farther into the Maritimes.

The days of winter allow everyone to linger and chat longer over a cup of tea. Children, both young and old, are excited by the marvellous new opportunities presented, such as sledding, skating, and playing hockey. Winter is special on Campobello Island—its magic is seldom captured by folks from far away.

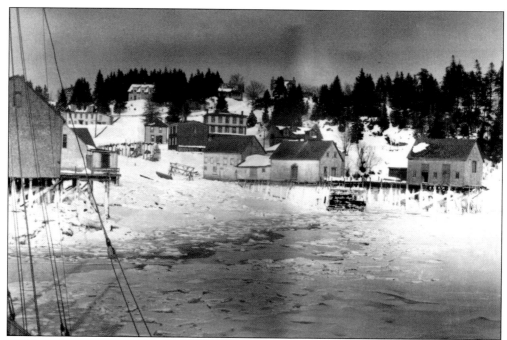

Welshpool is seen in winter *c.* 1920.

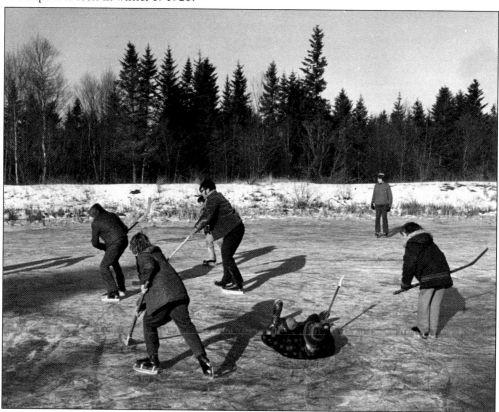

Winter is the season for hockey games, such as this one on Lake Glenseveren in the early 1950s.

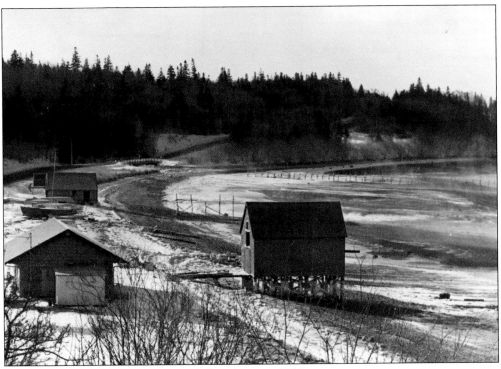

Herring sheds stand the cold at Friar's Bay during a 1950s winter.

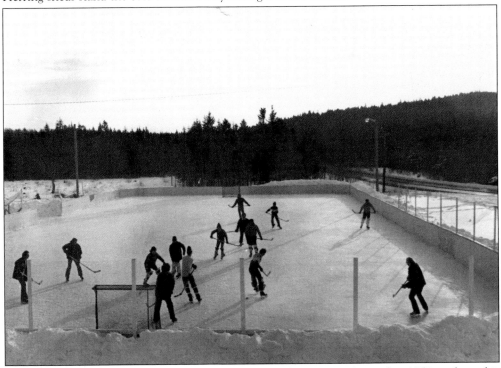

The Campobello Island Recreation Council opened a new rink in the 1950s, when this photograph was taken.

This winter scene at the Christian Camp site at Wilson's Beach dates from c. 1960.

Kathy Savage Smart and her black lab Hobo are shown at Wilson's Beach in January 1962.

126

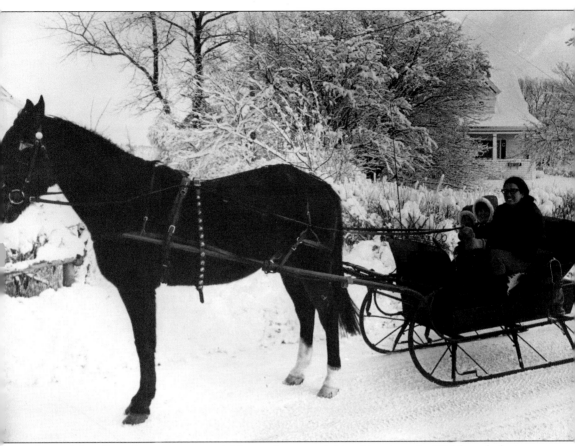

Joyce Morrell and two young neighbours have a sleigh ride through Welshpool during the 1960s.

ACKNOWLEDGMENTS

The authors wish to thank the following: Murray Alexander; Ronald E. Beckwith; the Border Historical Society; Raymond Brown; Campobello Gift Shop; the Campobello Public Library and Museum and staff; Campobello Royal Canadian Branch No. 83; Glenna Cline; Sheri Coates; Family Fisheries Ltd.; Ivan Firlotte; Franklin D. Roosevelt Library, Hyde Park, New York; Friar's Bay Motel & Restaurant; Herring Cove Provincial Park, New Brunswick; Dan Hogan; Terry Holt; Marjorie Lank; Rev. Richard Lembo; the Joan Lord Historical Collection; Rev. Brother Todd McGuire; Janice Meiners; Stephanie Milbury; Joyce Morrell; Ann Newman; Owen House & Gallery; Harriet Parker; Lucy Pelletier; Gordon Phillips; Roger W. Quirk; Quoddy Tides and Quoddy Tides Foundation; Carole Rice; the Roosevelt Campobello International Park Commission and staff; St. Anne's Anglican Church; St. Timothy's Catholic Church; Rev. Charles Smart; Kathleen Savage Smart; Rev. Jerry Vander Veen; Wilson's Beach Baptist Church and archivist Mark Renovich; and Wilson's Beach Pentecostal Church.

Other *Images of America* titles by Jim Harnedy:
The Boothbay Harbor Region
Around Wiscasset
Best of Maine (Selections)
The Machias Bay Region (with Jane Diggins Harnedy)

Also by Jim and Jane Diggins Harnedy:
A Handy Guide for Eucharistic Ministers, 2001 (Alba House)